Photography or Life Popular Mies

COLUMNS OF SMOKE / VOL. I

Juan José Lahuerta

Translated by Graham Thomson

TENOV BOOKS

First published in Spanish in *Humaredas. Arquitectura, ornamentación, medios impresos* by Lampreave in 2010.

Revised edition published in May 2015.

© of the text: Juan José Lahuerta

© of the translation: Graham Thomson

© of the images: their authors (See detailed list p. 166)

© of this edition:
Editorial Tenov
Casp 147
08013 Barcelona
tenov@editorialtenov.com
www.tenovbooks.com

Design by TENOV and Hector Aspano
Printed in Norprint, Barcelona

ISBN: 978-84-939231-4-3
DL: B9034-2015

CONTENTS

'Well, less is more, Lucrezia: I am judged'

Robert Browning
'Andrea del Sarto', 1855

PHOTOGRAPHY OR LIFE

Photogenic, Unphotogenic

In 1910, in *Architektur,*[1] Adolf Loos wrote: 'It is my greatest pride that the interiors I have created are completely unphotogenic.' And he continued, ironically: 'I have to forego the honour of having my works published in several architectural magazines.' Years later, in 1924, in an article entitled 'Von der Sparsamkeit' ['On Economy'],[2] he insisted: 'I am against photographing *intérieurs.*' At different times, therefore, Loos was perfectly clear about his lack of faith in photographs to convey what architecture, and especially the architecture of the interior of the house, is or ought to be. In the article from 1924 he stated in no uncertain terms and at greater length than anywhere else his outright opposition to photographing such interiors, and went on to declare heatedly that photography has the power to dematerialize everything to which it is applied, to distance it and freeze it, while interior architecture is based precisely on the closeness and sensory quality of materials and bodies, on the tactile presence with which life comes into contact with things, availing itself of the material world to which it belongs, and not on the visual distance that photography imposes. How, Loos insists, could a photograph recreate the comfort of a chair, the touch of its wood, the enveloping sensation of security? Loos's particular form of phenomenology strives to tell us that while the purpose of architecture is to serve life, and as such it can only be defined, like life, in terms of experience, photography, in contrast, abstracts and intellectualizes sight, and in so doing stylizes and 'aestheticizes' both life and architecture.

When we look at the photographs of the houses Adolf Loos built in the early years of the twentieth century—almost all of them taken in the last years of his life, from about 1930, when publications and tributes to him seem to begin to create a need for reproductions of his work—the first thing we notice is how conventional they are. There are symmetrical frontal views of the most representative parts of the house, such as the dining room (see the Langer house from 1901 [fig. 1], the Khuner house of 1907 [fig. 2], or the Löwenbach house from 1913 [fig. 3], to cite a few), and seemingly more casual diagonal views of the more intimate corners, generally arranged around a fireplace (as in the Langer house [fig. 1], once again, or Loos's own home, from 1903, among others [fig. 8]). What is more, all of the shots are taken from eye height, with nothing distorted or forced, so that what they seem to be trying for is a kind of naturalness of the eye, as close as possible to the more or less absent-minded glance that a person who frequented those places would usually give them. Loos may have gone round with the photographer, indicating the shots, though that would not have been necessary; it is the architecture itself that directs these views.

In 1898, in 'Ein epilog zur Winterausstellung' ['An epilogue to the winter exhibition'],[3] Loos had written that while the living-room is a place of private, individualized comfort—indeed, he imagines it as a sort of gentleman's club: 'the complete "suite" is finished; the individual armchair takes possession of our living-rooms'—the dining room, on the other hand, is a more formal space in which 'each individual willingly gives up some of his personal comfort in order to facilitate a more homogeneous meal'. This is exactly the point of view or position offered us by these photographs, which make us forget that between us and the interiors—Loos's interiors—a camera has been interposed, with all that is involved in the act of taking a photograph, and make us feel, if not 'inside' those places, at least that we are no strangers to them.

In this light it is striking to note how closely Loos's distrust of photography's intrinsic eloquence coincides in those years with that of Heinrich Wölfflin. Similarly concerned about the issue, in 1897 Wölfflin wrote a long article—expanded in a second edition in 1914—on how sculpture in a museum should be photographed, setting limits on the photographer's freedom of interpretation and requiring that the photograph be the deposit in which the point of view that the work demands—almost always a single one—coincide with the *habitual* view of the museum visitor.

fig. 1

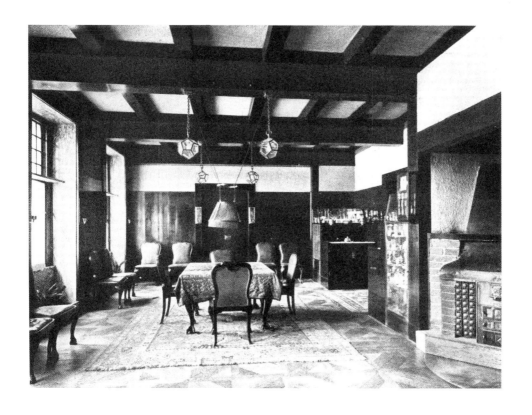

1901

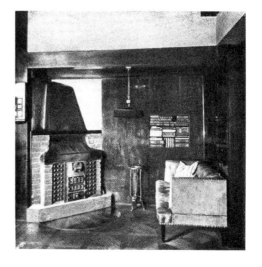

Abb. 11/12. Wohnung Leopold Langer, Wien
Eßzimmer

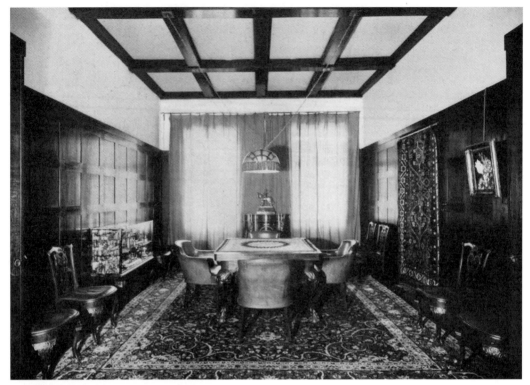

fig. 2

fig. 3

As for Loos, so for Wölfflin too photography is at best a lesser evil: any attempt by the photographer to interpret the subject photographed can only lead the viewer into grave misunderstanding.[4]

No less conventionally—we need only take a look at the interior decor magazines of the time, or the stunning advertisement for F. O. Schmidt that Loos published in *Das Andere* [fig. 6]—these interiors are always unoccupied, and it is worth pausing briefly here to consider this. In the photographs of Loos's shops—and these are contemporary with their construction—with the multiplicity of reflections in their windows, vitrines, counters and mirrors, we occasionally glimpse a human silhouette, a shadow cast or reflected (something that *always* occurs, I must insist, in the magnificent photographs of the offices and fitting rooms of the tailors Goldman & Salatsch in 1898) [fig. 4, 5, 7]. Reflections that ricochet and dematerialize; profiles blurred and lost: both show the condition of such places, traversed by the modern *res publica* which is merchandise, exactly the same condition that required that these photographs should be taken when they were, and not a day later.

In the photographs of the interiors, however, although there are no people—and still less, of course, silhouettes or ghostly shadows—and although some representative spaces tend to be dominated by large mirrors and their multiplying reflections, as we see in the dining rooms or lobbies, there has been an attempt to evidence the traces of living. There are no people, as I say, but signs of them remain: there are rugs, cushions, slightly creased or worn upholstery, hats or overcoats lying around, figurines, ashtrays, books left any old how on the shelves... Considered in this light, the photograph of the fireplace in Loos's own home [fig. 8], which I briefly mentioned above, taken around 1930, is exemplary. Let's compare it with others that are more contemporary, or more familiar. There is, for example, one from that same year of its construction, in which Loos and his wife Lina Obertimpfler are sitting on the brick benches on either side of the fire [fig. 9]. The furniture and objects have not yet arrived—on the left we see bare boards and remnants of the builders' work—but the fire has been lit as a symbol of the warmth that will permeate everything. In another photograph [fig. 11], taken in or around 1909, we see the alcove between the fireplace and the window: the walls are covered with paintings and curtains and the floor with rugs, the shelves with books, and the whole place is full of objects of all kinds, from little individual pieces of furniture—the stool and occasional table are almost a hallmark of these interiors—to ceramics, runners, cushions and clocks.

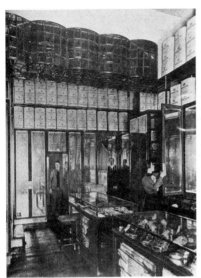 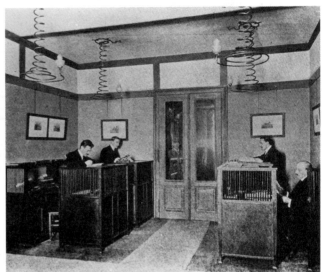

fig. 4, 5

F. O. SCHMIDT, I. SINGERSTRASSE 16 (PALAIS BRÄUNER) LADET ZUM FREIEN
BESUCHE SEINER AUSSTELLUNGSRÄUME HÖFLICHST EIN.

fig. 6

fig. 7

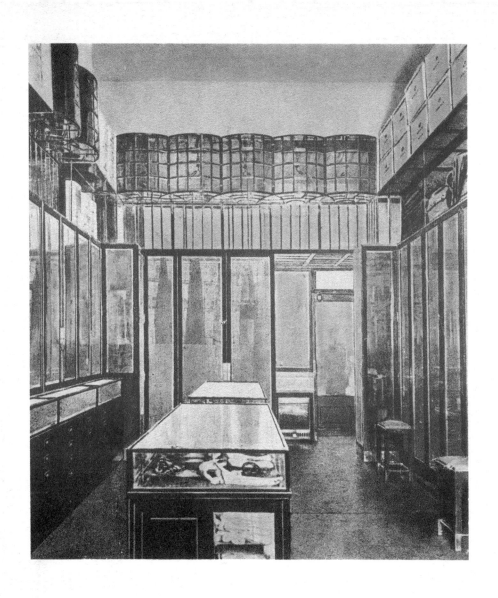

1. MAGASIN DE TAILLEUR POUR HOMMES
GOLDMANN, Vienne 1898

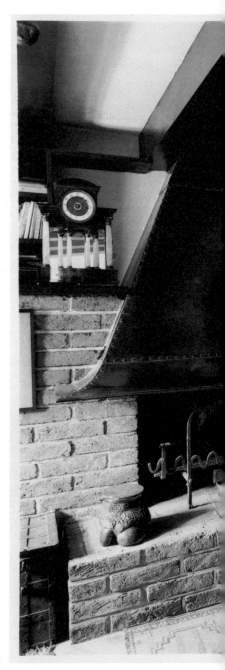

fig. 8

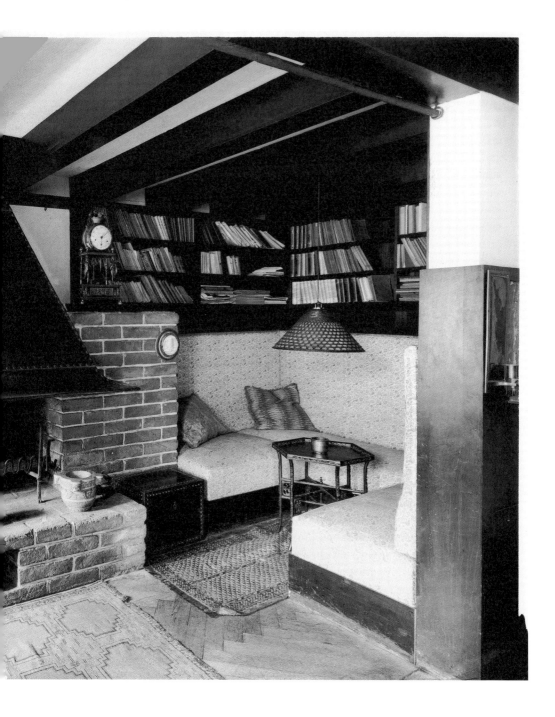

In another picture [fig. 10], from 1929, taken by Claire Beck, who married Loos that year, he is standing in front of the fireplace, feet together, in the middle of the frame, looking straight at the camera, and they are still there, the clocks, the ceramics, the iron tools, and the warm light slanting in from the window on the left, here out of the shot. His feet stand on a rug that in the earlier photograph [fig. 8] was in the corner by the sofa: treasured things moving around. The 1930 photograph that I mentioned at the outset [fig. 11]—taken looking into the blind corner, and much more official, with its rather *trop bien fait* clutter—nevertheless seeks to conserve all of this intimacy: the raking light coming from the left, evidenced by the lengthening shadows of the objects on the bench (the ceramics, the ironware), as if striving to penetrate the gloom of that soft corner. On the floor, in the middle, we see the rug on which Loos planted his feet and behind it another rug, wedged into the small space, one corner folded back as if we might trip over it 'again'; a sign at once intimate and on public display, then, of the extremely tactile use of this interior, and a casual detail from which, thanks to the character of the photograph as an impression, once we have seen it, we cannot look away: the impression on the rug and the photographic impression mutually amplify one another.

Although he never wrote a treatise on the subject, Loos knew, like Jules Vabre or Bouvard and Pécuchet, about 'l'incommodité des commodes' and the often unsatisfactory material texture of everyday life. These are also the 'unexpected' details that struggle to emerge in the photographs, that scratch at our eyes. In the photographs of Loos's interiors the typical untidiness is not only present but subtly touted, and is what warms his interiors. The photograph, which is what makes us aware of these little carelessnesses, at the same time disappears into them. Obviously, this requires that the interiors have no occupants, because we are the occupants, perfect habitués, familiar with everything—our own traces, in a photographic 'carelessness'—and anything but intruders.

'There are architects who build interiors not for people to live well in them, but to look pretty when they are photographed,' Loos said in that 1924 article. The truth is that it would not be long before the changing fortunes of his life—his time in Paris, the glamorous avant-garde and popular commissions, international dissemination of his work, tributes at the end of the decade—led his photographers to fall fatally into that temptation. From the late twenties, when rationalist and functionalist architects (or architects so called) began to regard him as a precursor or a master,[5] some of Loos's houses can be seen to resemble those of his supposed disciples, at least—and this is what interests us here—*in photographs.*

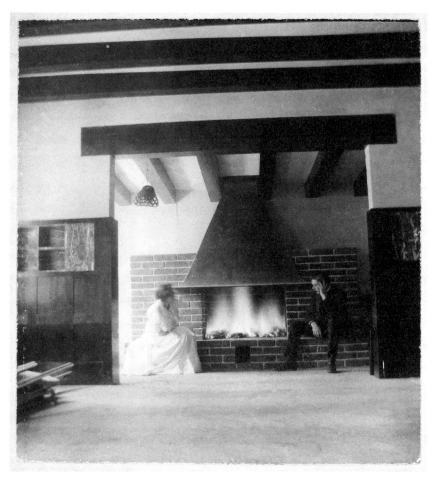

fig. 9

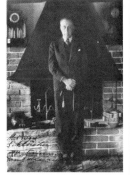

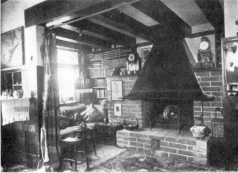

fig. 10, 11

It was precisely these photographs that for a long time served to illustrate Loos's work in the publications of the Modern Movement, creating a great misunderstanding of the true meaning of both his architecture and its representation.

Let's look at the photograph [fig. 12] of the smooth symmetrical walls of the staircase in the Tristan Tzara house, from 1926, punctuated by three African masks, or, indeed, those of the Müller house [fig. 13], from 1928, with their virtually empty interiors and their diagonal views that transform the spaces into an absolutely abstract interplay of planes and counter planes: these are the stylized, 'dematerializing' photographs that were to make Loos a modern architect in Paris circles in the late nineteen twenties and early thirties; Loos, 'one of our own'. It is true that, without searching any further, we need only compare the aforementioned picture of the stairs in the Tzara house with other, less formal and more intimate photographs of the same house [fig. 15], crammed with its owner's omnifarious furniture and bibelots, to be aware of the fallacy. But the fact is that the photos of Loos's first houses, which we considered above, aesthetically and technically conventional, with their interiors stuffed with equally conventional objects and furniture, and full of signs of life, could not, at the end of the nineteen twenties, represent a 'modern architect'.

The Loos who felt that the photographs of the interiors of his houses were incompatible with what those interiors were, to the extent of declaring himself opposed to having them photographed, represents, in the sphere of relations between modern architecture and photography, a position that very few—not to say nobody—adopted. Since we have mentioned him, the stance taken by Le Corbusier can be seen as very different from, and even diametrically opposed to Loos's. Surely Loos had Le Corbusier specifically in mind when he made his remark about architects who build their houses to look pretty in photographs?

If the issue here is between architecture and photography, or between photography and life, as Loos posited it, it may be worth recalling now an anecdote of Julius Posener's. It seems that, one day in the early thirties, Le Corbusier turned up at the editorial offices of *L'Architecture d'Aujourd'hui* and asked Posener to accompany him on a visit to Villa Stein. Built in 1927, the Stein's had just sold the house to some Dutch people called Stijn, and Le Corbusier thought he could at last take some photographs of the interior with good furniture, because he had

fig. 12

1926

Abb. 216/217. Haus Tristan Tzara, Paris
Stiegenaufgang und Sitzzimmer

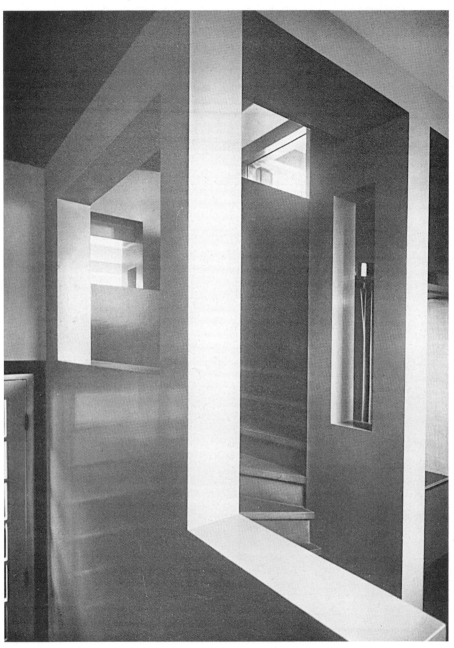

fig. 13

fig. 14

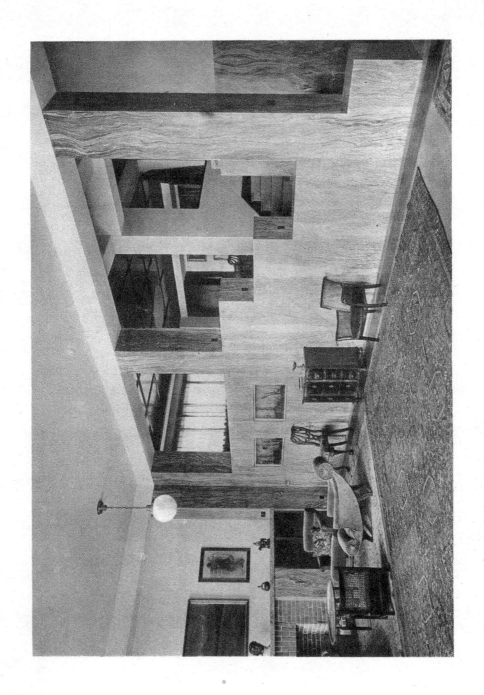

31. MAISON MÜLLER
Prague. (Hall) 1930

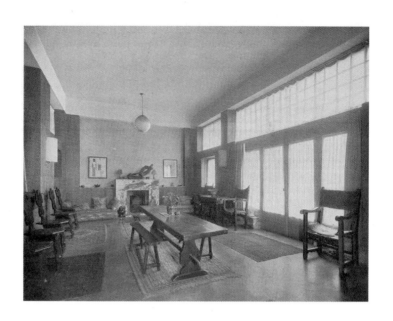

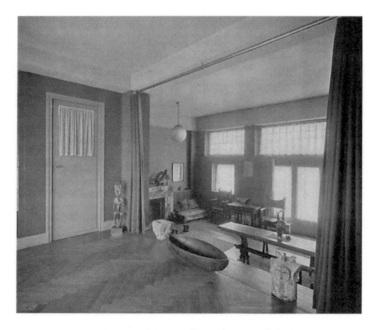

Abb. 214/215. Haus Tristan Tzara, Paris
Halle und Blick vom Speisezimmer in die Halle

always found the original owners' furniture horrible. When they arrived at the house Le Corbusier asked Posener to wait in the car while he went inside to take a look. He came straight out again, utterly downcast, and remarked that the Stijns had bought the house not because he had designed it, but in spite of that fact: apparently it was near the golf course, and that made up for all of its shortcomings. Posener was interested: 'And the furniture?' 'Need you ask?' was Le Corbusier's laconic reply. It goes without saying that the photographs were never taken.

The fact is that in radical contrast to Loos, Le Corbusier always eliminated every trace of life from photographs of the interiors of his houses. Indeed, he actively sought in them the very thing that Loos considered an abysmal failing: stylization, in the strict sense that, in relation to his architecture, the photographs are the best demonstration of a will to style imposing itself on life, on living. There is, in effect, no 'inhabiting' in the photographs of Le Corbusier's interiors, only abstract suspension and theoretical narrative.

But let's look, before moving on, at some of the photographs that Le Corbusier had taken of the Villa Stein, of which a few were published in the first volume of the *Oeuvre Complète* in 1929 [fig. 20], among other places [fig. 16, 18]. As in the case of Loos, here too the photographs are conventional, technically, formally and in other ways: that is to say, they do not impose themselves on what they represent but rather seem to disappear—they are clearly a medium. However, what they show is something else: absolutely empty interiors, literally stripped bare—curtainless windows, walls without pictures, uncarpeted floors, shelves with no books—in which there very occasionally floats some exasperatingly solitary, *trouvé* object deliberately placed there by Le Corbusier to 'react' with that airy emptiness: sometimes a Thonet chair [fig. 16] (Loos, incidentally, believed that Le Corbusier chose the wrong Thonet model)[7] but, as a rule, a garden chair, abounding in unexpected curves, form in suspension against the plane. These could be called 'exemplary photographs', and quite clearly they were, if we bear in mind the tremendous influence they have had on twentieth-century architecture: in them, Le Corbusier throws himself into the interpretation of his work and, as I have said, into the most radical definition of his style.

One of these photographs [fig. 20], which Le Corbusier liked to publish full-page,[8] shows the first floor looking towards what he called the 'library', though in fact there are no books to be seen, nor shelves.

fig. 15

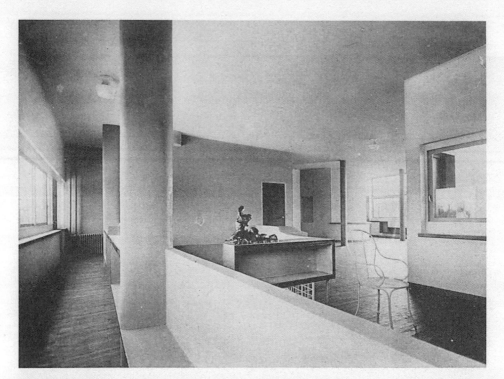

L. C. ET P. J.
VILLA, A GARCHES, 1927

9

fig. 17

fig. 16

following pages fig. 18, 19

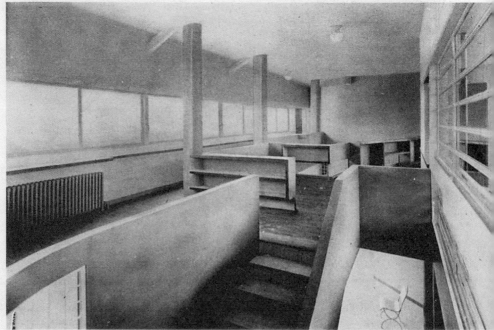

réunion par un gentil petit truc : elle assit à table chacun des peintres bien en face de l'endroit où étaient accrochés ses tableaux. Personne ne s'en douta, ils furent ravis sans arrière-pensée, mais comme on se séparait, Matisse, le dos contre la porte, en jetant un dernier coup d'œil sur la pièce, comprit ce que Gertrude Stein avait fait.

Un jour du printemps 1922, nous allâmes visiter le nouveau salon des Tuileries.

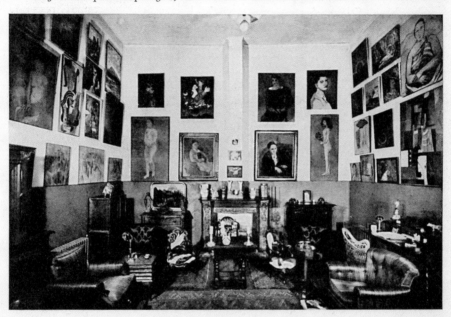

FIG. 5. — L'ATELIER DE M^{lle} GERTRUDE STEIN. (État actuel.)

Jane Heap avait beaucoup parlé d'un jeune Russe dont l'œuvre l'intéressait. Nous vîmes ses tableaux et Gertrude Stein les trouva aussi intéressants. Naturellement il vint nous voir.

Dans l'Art d'écrire, Gertrude Stein écrit cette phrase : « La peinture, après sa période glorieuse, est redevenue maintenant un art mineur. »

Elle était très curieuse de découvrir le grand homme de cet art mineur.

Et voici toute l'histoire.

Le jeune Russe était intéressant. Pour peindre, il disait qu'il employait une couleur qui n'était point de la couleur, il peignait des tableaux bleus, et trois têtes sur le même corps. Picasso déjà avait peint trois têtes en une seule. Bientôt le Russe se mit à peindre trois corps en un seul. Était-il le seul ? Oui, d'une certaine façon, bien qu'il fut entouré d'un groupe. Ce groupe, peu après que Gertrude Stein eût fait la

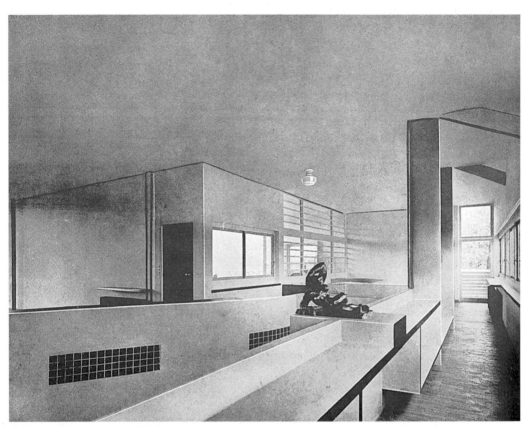

fig. 20

fig. 21

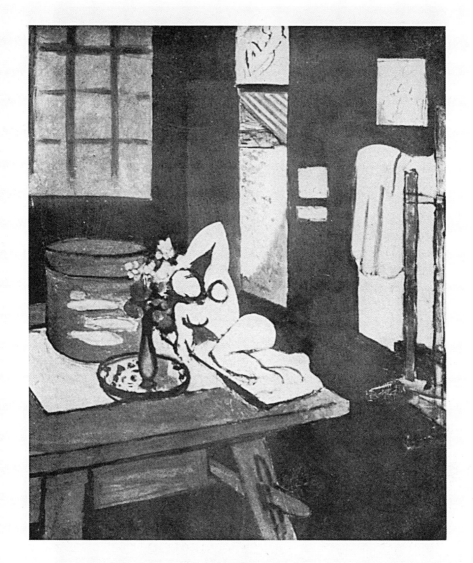

MATISSE Photo Druet

Opening on the left is the void of the lobby, over which Le Corbusier cantilevered a ledge that supports a small bronze by Matisse, *Nu allongé*, the first version of which is from 1907, and was in the Steins' collection. And, incidentally, what were they like, the celebrated Paris apartments of the Steins [fig. 17, 19]? At different times, Gertrude and Leo, and Michael and his wife Sarah, the owners of the villa, resided at 27 rue de Fleurus, and at 58 rue de Madame, with their heavy tables of dark wood with turned legs, their armchairs, their coffers and chests, their sideboards covered with ceramic and metal pieces and ancient, modern or exotic sculptures, their lamps with fringed shades, their sofas smothered in cushions and rugs and their walls absolutely covered with paintings: their Cézannes, their Matisses, their Picassos...

In many of his writings Le Corbusier advocated keeping walls bare and paintings out of sight, stored away in what he called a *casier à tableaux*: only when the owners felt the desire to look at them should they be fetched, like a book, and then put back again when the desire was satisfied. If the relationship that Le Corbusier proposed with things in this austere concentrating is purely intellectual, that suggested by these apartments and studios of the Steins is absolutely visual and thoroughly tactile, the one thing for the other and in the other, and is enacted in a lavish and lush wandering: in them everything overflows, everything is excessive, because everything wants to be contemplated at the same time, to be engaged at the same time, to be possessed at the same time. But there is an even more direct comparison with the Matisse. Precisely this sculpture that floats in isolation in the photograph of the Villa Stein, the *Nu allongé*, had been represented in many of the artist's paintings as one of the elements in still-lifes that contribute to the warm and crowded interiors, saturated, bathed in a dense and brilliant light, which are so characteristic of his work [fig. 21].[9] In them, life is represented by ornament, by the twisting tendril that insinuates itself into everything and the arabesque that leaps from side to side, giving form to all things and colonizing every surface: from the languid figurines to the goldfish and the vases of flowers and fruit to the printed rugs and wallpapers... In the midst of this ornamental exasperation, the *Nu allongé*, like Galatea in the Pygmalion story, comes to life, becomes animate and incarnate, just the opposite of what happens in the photograph by Le Corbusier, in which the Matisse sculpture is nothing but a hard, black, shiny cake of carbon or asphalt standing out, in absolute solitude, against the ample smooth white planes of the walls and ceiling, in the total nudity of a house that is *unornamented—*or *dispossessed.*

I referred to Galatea: Le Corbusier petrifies once again the only one of all figures of the metamorphoses where stone turns to flesh, rather than the other way round. Perhaps that is an apt metaphor for what he was looking for in the photographs of his works: how else but by cancelling out any sign of life in them could they be converted, as he desired, into paradigms of style?

Loos was suspicious of photography and rejected it because he interpreted his architecture sensorially; Le Corbusier discovered the effectiveness of photography because he, in contrast to Loos, sought to represent his architecture as a closed thing, *cosa mentale*. However, the two extremes touch at one point: both saw photography as a medium, and denied it any agency of its own. I have already referred to the conventionality of the shots, the techniques and the framing. At the same time, the photographer is never credited by name, being regarded as merely an anonymous tradesman (exceptionally, in a footnote in *Toward an Architecture* Le Corbusier briefly pays tribute to Frédéric Boissonnas, whose photographs of the Parthenon illustrate the book, in just such terms of professional ability)[10]. The photographer, like the camera he uses, is an instrument subordinated to the architecture, or, more precisely, to its representation. Neither Loos nor Le Corbusier could accept that photographers should impose their point of view, or even that they could have one.

If until now we have regarded Loos and Le Corbusier as antithetical to one another, it is because we have been talking about the possibility or otherwise of the photographic representation of modern architecture. Now, however, we can place them together at the same extreme, among those who refuse to grant photography any independence, as opposed to those who take the very different view that modern architecture can be expressed all the better thanks to the language that photography—no less modern and autonomous than architecture—has forged for itself.

Undoubtedly, the place where the belief that architecture and photography could mutually enhance their powers and virtues was most strongly held was the Bauhaus. Two things must be taken into account here. On one hand, it was there that the theoretical definition of the so-called 'New Vision' crystallized, and where László Moholy-Nagy published his foundational *Malerei Fotografie Film* in 1925 in the

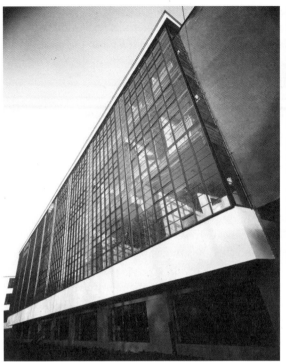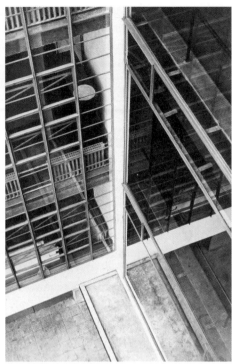

fig. 22, 23

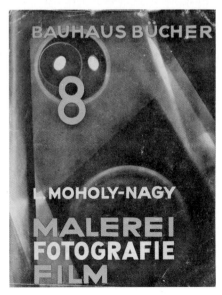

fig. 24

Bauhausbücher collection [fig. 24];[11] on the other, the Bauhaus building designed by the school's director Walter Gropius, in 1925 and opened in 1926, was immediately hailed, and not only in Germany, as a paradigm of modern architecture. *Ergo*: as far as the relationship between photography and architecture is concerned, the *locus classicus* for the experiments of the 'New Vision' was, of course, the Bauhaus building itself. A truism, then.

On completion of the construction work, Lucia Moholy produced a magnificent photo-essay [fig. 22] that established the definitive points of view both modern and official—or rather, official because so modern—of the new Bauhaus. On this basis, two parts of the building were shown to be particularly suited to the purposes of the photographers and students of the Bauhaus and to the aspirations of its architects: the great glass façade of the workshop block, and the studio building, known as the Prellerhaus. It goes without saying that the viewpoints of these photographs correspond perfectly with all of the formal principles of the 'New Vision' [fig. 30]: high- and low-angle shots, off-centre framing, diagonals, straight and reverse shots [fig. 23]... In complete contrast to what we find with Loos and Le Corbusier, where the photographic subject is clearly centred on the interior, with the Bauhaus the experiments are always conducted out of doors, while the shots of the interiors, even Lucia Moholy's foundational photographs, are much more conventional.

In truth, however, we could say something more: it is not so much that the photographs of the Bauhaus building are exterior shots as that they seem to seek the exasperation of the exterior, the paroxysm of the surface. Thus, with the workshop block, the most attractive option was to show the homogeneity of the curtain wall, the hardness of its dark mirror shine, but also its transparency, its slenderness and independence of the structure, especially in the way in which, overlapping its planes, it turns and doubles back at the corner. In the case of the studio building, the option was even clearer: almost always, if not always, the chosen moment is one in which the steeply angled sunlight casts across the façade the tense, elongated shadows of the balconies.

Regular distribution of the balconies precipitated in the serial barring of their shadows, smoothness of the plane hystericized by the caress of the parallel shadows, orthogonality of the architectural composition tensed by the diagonality of the photographic shadow... Some, like Loos and Le Corbusier, if for very different reasons, might think it is not photography that is at the service

of architecture but that with architecture converted into pure surface, screen of shadows, just the opposite occurs. Indeed, is this not what we see in every aspect of life at the Bauhaus? No doubt, this school is one of the first places in which we discern the photographic excess that will be characteristic of our age. Continually, irrelevantly, incessantly and tirelessly, the students and teachers of the Bauhaus took photographs and posed for them: in the privacy of their rooms, in the collective endeavour of the workshops or in the publicity of their parties and games, which, moreover, contaminate everything. In modernity as understood by the Bauhaus—and we need only look around us to perceive the disturbing heritage it bequeathed us—everyone is, in effect, happy and carefree (everyone laughs, dresses up and clowns around in these photographs) and what is more no one goes anywhere without a camera to record for eternity the most trivial nonsense, because everyone is a photographer and everyone loves to be photographed. So it is that the classic mistakes of the amateur—subject not centred, out of focus, tilt, distorting high and low angles, double exposures, violent chiaroscuro, shadows...—are amplified with those unmistakable synchronized poses of people dancing or on parade and larky attitudes of classmates in the playground, on the playing field or on excursion or of comrades in the academy, usually military or sporting (or more likely, both), jumping, dancing, throwing a ball, making faces, marking time, lying on the sand tracing figures, making horns with their fingers behind someone's head, always laughing, as I said, looking into the camera... and in so doing stringing together a perfect series of clichéd mystifications of modernity (not so much romantic or bohemian as merely undergraduate), in which youth is synonymous with uninhibited joy or formal experimentation with social revolution, etc. etc. Gropius's building is the constant background in this great family album, its perfect chinoiserie screen: almost all outdoor activities at the Bauhaus took place on the lawn in front of the Prellerhaus [fig. 27-30], so that its grid of balconies is the fixed backdrop for dancing or sport or is transformed, using the balconies as theatre boxes [fig. 29], and always in forced low-angle shots, into stage machinery. Isn't this the modernity that 'thinks itself'? That is what seems to be suggested by another set of quintessentially Bauhaus photographs: those in which the double exposure of the negative [fig. 25, 26] has superimposed a face—usually pensive—on an image of the building. *Ex machina*, of course: how else could modern architecture 'think itself' other than by 'seeing itself' fresh out of the camera?

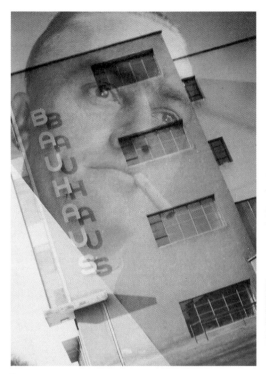
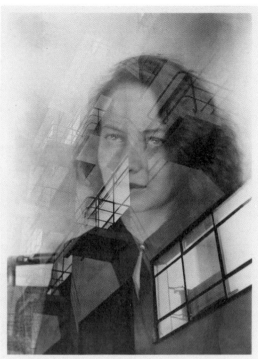

fig. 25, 26

fig. 27, 28
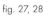

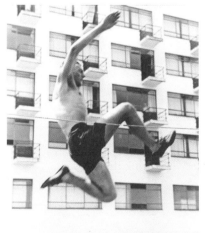
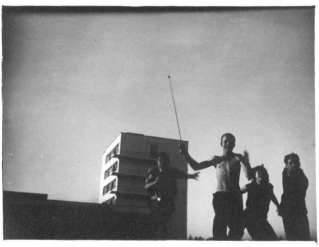

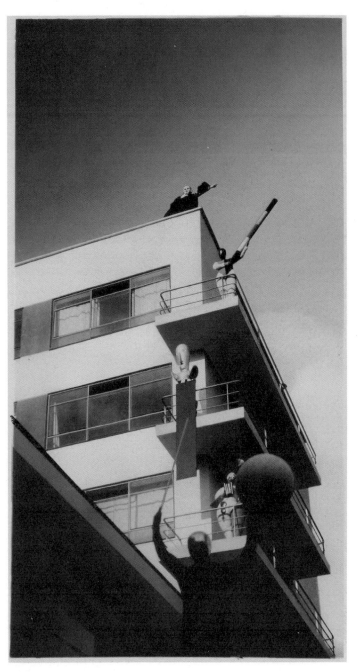

fig. 29

fig. 30

Neue Wege der Photographie

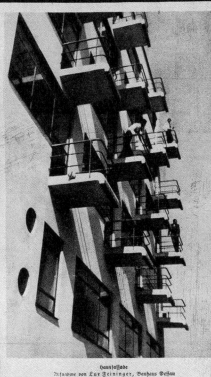

Hausfassade
Aufnahme von Lux Feininger, Bauhaus Dessau

Röntgenaufnahme einer perlengestickten Tasche mit Inhalt
Aufnahme des Lettevereins, Berlin

Zwei Gesichter
Aufnahme von Lux Feininger, Bauhaus Dessau

Simultanporträt
Aufnahme von Otto Umbehr

The Cross and the Wheel

Camera, machine, factory: let's see where these dreams take us.

In October 1927 Charles Sheeler[12] received a commission from Vaughn Flannery, then director of the Ayer & Son advertising company, for a photo-essay on the huge Ford Motor Company plant in Dearborn: much of it built to plans drawn up by Albert Kahn—Le Corbusier turned it into one of the paradigm images of *Toward an Architecture* and *Urbanism*—the famous Rouge Complex [fig. 32] a few miles outside of Detroit city was a virtual city in its own right, employing up to 75,000 people.

However, those were not good times for Ford. In May 1927 the company had ceased production of the Model T (over 15,000,000 cars sold in ten years) and the future of the firm, beset by competition from other car makers, especially General Motors, largely depended on the economical new car then being produced almost in secret, the Model A, which was to be launched in December. In the final months of the year Flannery put together an aggressive advertising campaign that culminated in the presentation of the car before a large crowd at Madison Square Garden in New York, and in fact by Christmas Ford had received more than one million orders for the brand new Model A.

fig. 31

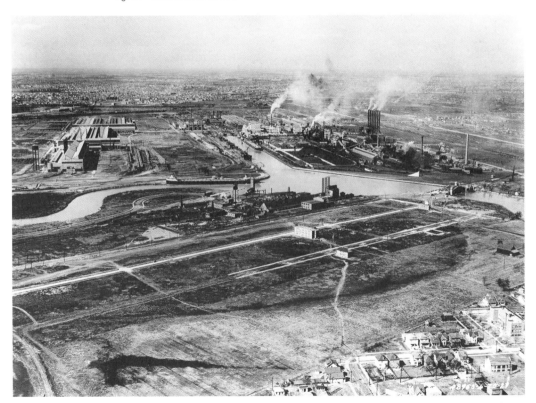

fig. 32

fig. 33

Sheeler, for his part, also seemed to be at a low ebb in his career. He had started out in the same circles as Alfred Stieglitz, Marius de Zayas and Walter Arensberg, and his 1921 film *Manhatta*, made with Paul Strand, had been hailed one of the great achievements of the first American avant-garde. In early 1926, however, anxious to concentrate on painting but unable to live on the sale of his canvases, he went to work for the Condé Nast magazine group, taking publicity photographs and portraits of personalities, almost always conforming to the dictates of the client. Although Sheeler was never very comfortable in this situation, and actually quit it in May 1929 to travel to Europe, he quickly gained a reputation as a *reliable* professional. His photographs, especially those of architecture and objects, were highly praised for their dignity and austerity—the qualities celebrated in them by Edward Weston[13]—and the very close close-ups [fig. 33], tightly pared framing and contrasts of light and shade made them paradigms of an already defined and even popular idea of modernity: the idea put forward by magazines such as *Vogue* and *Vanity Fair* in their photo-essays and full-page adverts. The same idea was at the back of the commission from Ayer & Son to photograph the Ford factories: the pictures were to be part of the great end-of-the-year launch campaign for the Model A.

If we bear in mind the specific ideas that Vaughn Flannery had for the Ford campaign, it is immediately evident that Sheeler was the most appropriate choice. Flannery was not interested in that aerial photographs and panoramic views that Ford had been using in brochures to show the immense scale of the facilities [fig. 32]. He wanted partial, fragmentary images in which the assembly bays and the machines that filled them would look very close, detailed and precise, as if they were all parts of the greater machine—gigantic, incomprehensible, and therefore fascinating—that was the plant as a whole. The aerial photo was a landscape, stunning, of course, but expressive in only one direction: that of the vastness of the factory. Perhaps, too, this was not a very desirable vision in the late twenties, just before the crash and the Great Depression, when the ideological strategies of American capitalism—of which the Model A Ford, a car for everyone, was a part—were beginning to be oriented more towards the organization than towards labour. The close-quarters view of a warehouse or a machine, a turbine, an elevator, a bridge, a wheel or a conveyor belt allowed a different kind of expression, focusing on the beauty of the object, of the machine itself, fused with what it produced. The part for the whole: the factory had to be seen, by way of its bright and clean fragments, as clean and bright too, a place where the notion of work as punishment, as painful effort or the exploitation of the workers, had no place.

fig. 34

The photographs had to show that the cars rolled out of the factory without difi-culty, as the simple outcome of a process. In fact the whole point was to create an image of the assembly line that, imposing its own rhythms, supplanted real time, fragmenting production and preventing any understanding of its totality, and eliminated the workers' experience of work [fig. 33]. It was the machine, and only the machine, that worked: these photographs had to make visible the dream of *per-petuum mobile* in which factory and toiling masses were to immerse themselves.[14]

During the six weeks of shooting the photographs, Sheeler was given every fa-cility to move around the factory. This was necessary, because most of his shots were taken at times of inactivity: the motors idle, the wheels stopped, the lines still. Movement is not a friend of the beauty that Sheeler, like his clients, under-stood in purely formal or, more precisely, objectual terms. That is to say, in classical terms. The machines in his photographs had to manifest the same *auctoritas* that emanated from classical architecture and sculpture, and their constituent parts were to reveal, without paradox, the ideas of *symmetria*, of *finitio* or of *concinnitas* with which the classical tradition had defined the balance, perfection and corre-spondence of parts and the whole. And the fact is that in these photographs, the machines or parts of machines, isolated from the world of work, of effort and of movement, immobile in their form, seem to coincide perfectly with Alberti's defi-nition of beauty, and, in effect, nothing can be added to them or subtracted from them. It was to just such exactitude beyond all contingency, monumental and solemn, that Marius de Zayas was referring in *Camera Work*, in 1913, when he op-posed pure photography to artistic photography, compressing in that word 'pure' an aspiration to technical perfection and a moral imperative.[15]

In fact, this desire for technical perfection, for objectivity, *is presented* as a moral necessity. Not only had Sheeler formed himself in Zayas's ideas, he also in-terpreted them well. The photographing of machines represents the tautology in which that symbolism of the absolute culminates: one machine, the camera, refers to another, both reflected in a suspended instant. It is not surprising that in 1929, when some of the photographs Sheeler took in the Ford factories were published in *transition*, Eugène Jolas should have drawn attention to their 'puritan' charac-ter.[16] Moreover, that same fascination with the specular correspondence between cameras and machines, that same exasperated admiration for detail and for the series, was an essential part of the 'new objectivity' emerging in those years in Eu-rope, and particularly in Germany, as we have seen, and that could also have been called 'new objectuality': a moral and aesthetic ideology, one thing for another,

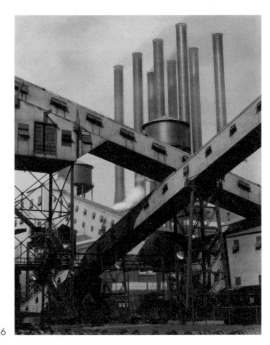

fig. 36

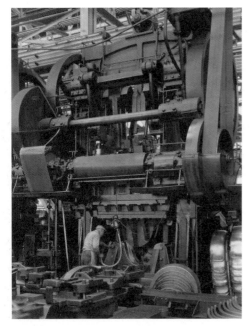

fig. 35

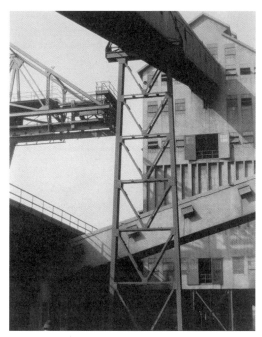

fig. 37

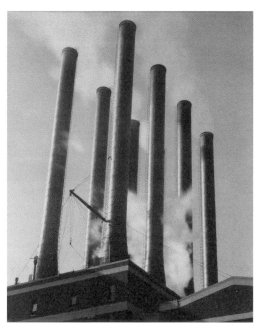

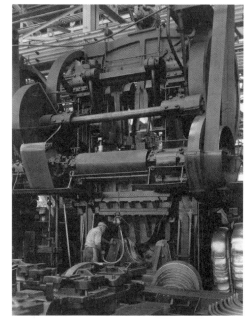

fig. 38

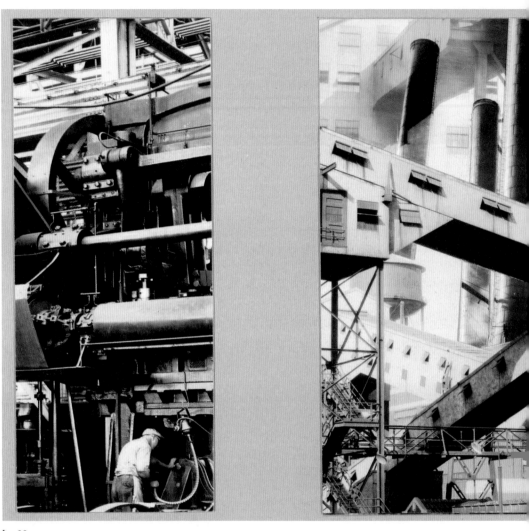

fig. 39

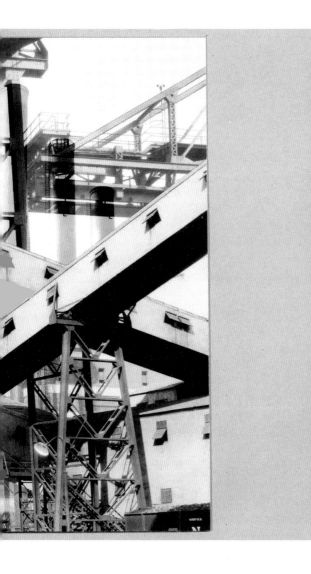
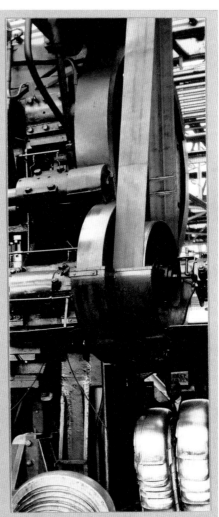

which reached its culmination in 1928 in the hugely popular book by Albert Renger-Patzsch, *Die Welt ist schön (The World is Beautiful)*.[17] The emblem on the cover of the book depicts a telegraph pole and a tree [fig. 31].

In Sheeler's photographs, then, the machines are stopped, but that is not all: there are scarcely any workers in them—and when they do appear they do so individually, engaged in relaxed tasks such as tidying or cleaning up at the end of the shift—and we never see and can hardly even imagine the process of producing a car: no cars, no recognizable parts of their assembly. What is produced in the giant factory Sheeler photographed? The solemnity of these machines, clean and forthright despite their complex systems of wheels, belts and gears, speaks to us of the processes occurring in the factory as something distant and hygienic, the work of a powerful and instantaneous god, and never of the days, the effort and the exploitation of men. What is produced, then, is the Product itself, understood as absolute and absent Beauty; Work as pure desire, or as pure Will, without work.

One of the most famous photographs in the series—*Ladle Hooks, Open Hearth Building* [fig. 34]—shows a high-roofed, almost empty bay traversed by steel gantries, and in the centre, suspended over the head of a worker, a giant hook, like a huge *objet trouvé*. On the right, the metal pillars recede into the distance, and light enters between them dramatically, as it would through a series of buttresses. In February 1929 this photo was published on the front cover of the company magazine, *Ford News*, with the caption 'The Cathedral of Industry'.[18] And this was not the only occasion that such images were associated with religious references. We have already referred to the comments of Eugène Jolas in *transition*, and in 1928, another photograph, also very famous, which shows two bisecting conveyor belts with eight towering chimneys behind—*Criss-Crossed Conveyors* [fig. 36]—appeared in *Vanity Fair* with the evangelical phrase 'By Their Works Ye Shall Know Them'.[19] Sheeler himself—who, incidentally, in April 1929 carried out one of his most important commissions in Europe: a series of photographs of Chartres Cathedral—wrote in an appraisal of his work that 'our factories are our substitute for religious expression'.[20] Several years before, in September 1922, Harold Loeb had written in *Broom* that 'like the Christian religion in the early centuries, the mysticism of money will become the force of the greatest aesthetic expressions.' His enormously influential article was entitled precisely 'The Mysticism of Money',[21] and was intended to point the way to a genuinely American art, which would of necessity come into being as an aesthetic decanting of the theological mysteries—to paraphrase Marx—of capitalism.

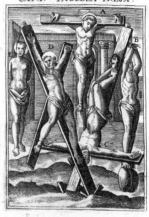

CAP. I. TABELLA PRIMA.

A D Sancti martyres in crucem, capitibus ad cælum eleuatis, tollebantur.
B Appendebantur quandoq; brachijs post tergum reuinctis: quandoq; pe-
 dione à diaboli ministris grauia pôdera à vinciri aliquando solebā̄t.
C Item cruci, capitibus in terram versis, affigebantur.
E Mulieres Christianæ capillis suspendebantur.

fig. 40

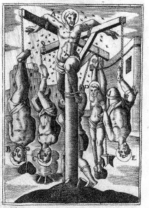

CAP. I. TABELLA III.

A SS. Martyres nonnunquam, vt muscarum & fucorum aculeis
 excruciarentur, stipitibus erectis, melle delibuti, radijsque
 Solis expositi appendebantur.
B Aliquando vel vtroque pede, ingentibus saxis ad eorum cer-
 uices alligatis.
C Vel altero pede, fumo supposito.
D Vel etiam apicibus pollicum manuum, eorum pedibus grani-
 bus additis oneribus.
E Vel demum altero quoque pede in genu deflexo, & genu fer-
 reo iniecto vinculo, altero deinde pede ferri pondere gra-
 uato.

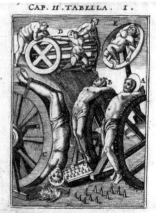

CAP. II. TABELLA. I.

A Martyres quandoque rotis, mucronibus vndique effixis, liga-
 ti, super cuspides ferreos circumagebantur.
B Aliquando, qui m̄ offixi non erant prænotati mucrones, super
 cuspides item ferreos.
C Aut saltem, vt misere vitam finirent, super ardentes prunas.
D Demum rotarum conuexi alligati, è loco sublimi præcipita-
 bantur.
E Aut rotarum radijs intexti, sic ad plurimos dies, vt interirêt,
 relinquebantur.

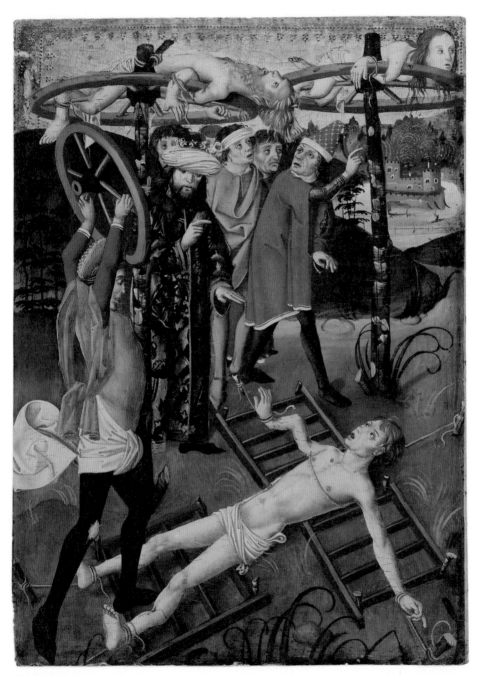

fig. 41

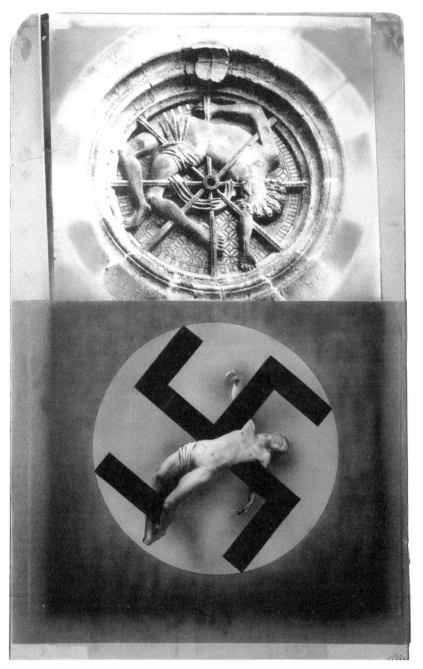

fig. 42

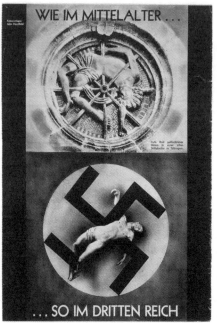

fig. 43

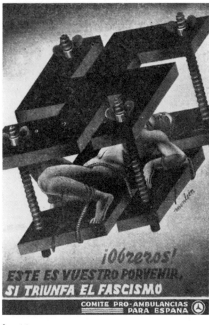

fig. 44

fig. 45

No wonder Sheeler almost always opted for a vertical format in photographing the interiors of the Ford factory bays, a kind of 'Gothic' format that identified them more closely with the elevated section of the mediaeval cathedrals. Thus, to the conflation of capitalism, spirit and nature effected in countless metaphors by Loeb and so many others, both in America and in Europe, Sheeler's photographs added the vision of the factory as a cathedral: that is, quite simply, the vision of industry and industrial work not as exploitation but as the work of all, a collective endeavour.

But is this mystification really so obvious? Perhaps not. In 1932, MoMA, in one of the many attempts to enlist American modern art in the propaganda effort aimed at combatting the moral effects of the Great Depression—and also, of course, to provide work for artists—organized an exhibition of murals extolling the power and values of work. Sheeler presented a piece entitled *Industry* [fig. 39], for which he used four images from his series on the Ford factories. He cut one of these pictures, *Stamping Press* [fig. 35], into two tall narrow halves, which he set on either side of an almost square picture in which the bisecting conveyors in a photograph we have already looked at, *Criss-Crossed Conveyors* [fig. 36], are superimposed, ghost-like, on the group of eight chimneys of *Power House N°. I* [fig. 38] and the (inverted) metal gantry of *Pulverizer Building* [fig. 37]. The choice of format, the triptych, is deeply significant: it directly invokes a typical form of devotional art, the altarpiece. This bestows an unexpected meaning on the things the triptych contains, and especially the criss-crossing bridges in the central panel. What they are now but a cross? And what can the elements that dominate the side panels be but wheels? A cross, flanked by two wheels: the 'Gothic' allusion is maintained, but now it is no longer a cathedral, and no longer obvious but subtle—or rather, unconscious—and refers to the punishment of the condemned [fig. 40, 41]. The torment of the cross and the torment of the wheel, as we see in so many mediaeval and Renaissance altarpieces in which the sufferings of Christ are represented: Jesus on the cross between the broken bodies of the two thieves.[22]

Unexpectedly, Sheeler's triptych becomes a modern crucifixion, and the cross and the wheel are, as in the past, the instruments of a new passion. Unexpectedly? Maybe not. In his *AIZ* photomontages, all later than 1932, John Heartfield frequently depicted workers crucified on swastikas, as well as Christ carrying a swastika, and factory chimneys as cannons. One of those photomontages, from May 1934, is of particular interest to us here.

Its title is *As in the Middle Ages... So in the Third Reich* [fig. 42, 43]. In the upper half we see a reproduction of a mediaeval bas-relief: a body broken on the wheel; in the lower half another body is pinned on the arms of a swastika. Monleón, among many others, was to reinterpret this figure of Heartfield's during the Spanish Civil War [fig. 44] but what is of more concern to us now is the version made in 1936 by Paul Strand, who had co-directed the film *Manhatta* with Sheeler. Strand's *Skeleton/Swastika* [fig. 45], which appeared on the front cover of the theatre magazine *TAC* in 1939, is unquestionably the most terrible of all.[23]

These two works, the Heartfield and the Strand, cast retrospective light on the triptych by Sheeler, who, unbeknown to himself, had looked forward to them. Or perhaps they cast not light but darkness. *Industry*: mystifications are no longer possible. Where would it lead, as intended or not, that love of machines and factories? In 1929, in 'Cheminée d'usine' [fig. 46], one of the entries of the 'Dictionnaire critique' published by *Documents*,[24] Bataille said that in his childhood nightmares, factory chimneys represented an even greater terror than church steeples. It is worth looking at the other side of things, because that is what comes out of the machine.

fig. 46

CHRONIQUE

DICTIONNAIRE

ABATTOIR. — L'abattoir relève de la religion en ce sens que des temples des époques reculées, (sans parler de nos jours de ceux des hindous) étaient à double usage, servant en même temps aux implorations et aux tueries. Il en résultait sans aucun doute (on peut en juger d'après l'aspect de chaos des abattoirs actuels) une coïncidence bouleversante entre les mystères mythologiques et la grandeur lugubre caractéristique des lieux où le sang coule. Il est curieux de voir s'exprimer en Amérique un regret lancinant : W. B. Seabrook (I) constatant que la vie orgiaque a subsisté, mais que le sang de sacrifices n'est pas mêlé aux cocktails, trouve insipide les mœurs actuelles. Cependant de nos jours l'abattoir est maudit et mis en quarantaine comme un bateau portant le choléra. Or les victimes de cette malédiction ne sont pas les bouchers ou les animaux, mais les braves gens eux-mêmes qui en sont arrivés à ne pouvoir supporter que leur propre laideur, laideur répondant en effet à un besoin maladif de propreté, de petitesse bilieuse et d'ennui : la malédiction (qui ne terrifie que ceux qui la profèrent) les amène à végéter aussi loin que possible des abattoirs, à s'exiler par correction dans un monde amorphe, où il n'y a plus rien d'horrible et où, subissant l'obsession indélébile de l'ignominie, ils sont réduits à manger du fromage. — G. BATAILLE.

(I) *L'Ile magique*, Firmin-Didot, 1929 (cf. plus loin, p. 334).

CHEMINÉE D'USINE. — Si je tiens compte de mes souvenirs personnels, il semble que, dès l'apparition des diverses choses du monde, au cours de la première enfance, pour notre génération, les formes d'architecture terrifiantes étaient beaucoup moins les églises, même les plus monstrueuses, que certaines grandes cheminées d'usine, véritables tuyaux de communication entre le ciel sinistrement sale et la terre boueuse empuantie des quartiers de filatures et de teintureries.

Aujourd'hui, alors que de très misérables esthètes, en quête de placer leur chlorotique admiration, inventent platement la *beauté* des usines, la lugubre saleté de ces énormes tentacules m'apparaît d'autant plus écœurante, les flaques d'eau sous la pluie, à leur pied, dans les terrains vagues, la fumée noire à moitié

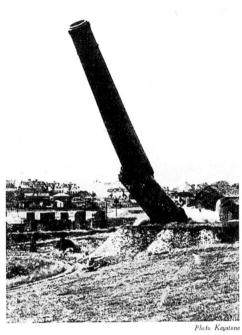

Photo Keystone

Chute d'une cheminée haute de 60 mètres
Banlieue de Londres.

rabattue par le vent, les monceaux de scories et de mâchefer sont bien les seuls attributs possibles de ces dieux d'un Olympe d'égout et je n'étais pas halluciné lorsque j'étais enfant et que ma terreur me faisait discerner dans mes épouvantails géants, qui m'attiraient jusqu'à l'angoisse et aussi parfois me faisaient fuir en courant à toutes jambes, la présence d'une effrayante colère, colère qui, pouvais-je m'en douter, allait devenir plus tard ma propre colère, donner un sens à tout ce qui se salissait dans ma tête, et en même temps à tout ce qui, dans des états civilisés, surgit comme la charogne dans un cauchemar. Sans doute je n'ignore pas que la plupart des gens, quand

NOTES

Photogenic, Unphotogenic

1. Loos, Adolf. 'Architektur', *Der Sturm*, 15 December 1910. Now in *Escritos II*, pp. 28-29. Madrid: El Croquis, 1993.

2. Id., 'Von der Sparsamkeit', *Wohnungskultur*, No. 2-3, Brünn, 1924, now in id., op. cit., pp. 208-209.

3. Id., 'Ein epilog zur Winterausstellung', *Die Zeit*, Vienna, 18 February 1898. Now in id., *Escritos I*, cit., pp. 234-238.

4. The Wölfflin articles are in *Zeitschrift für bildende Kunst*, Leipzig, VII, 1896, pp. 224 & ff.; VIII, 1897, pp. 294 & ff.; XXVI, 1914, pp. 237 & ff.

5. Le Corbusier wrote: 'Loos is one of the predecessors of the new spirit'; 'Loos swept under our feet, it was a Homeric cleansing [...]. With it, Loos influenced our architectural destiny.' 'Ornament' et crime, *L'Esprit Nouveau*, No. 2, p.159. Paris: Crès, November 1921.

6. Posener, Julius. 'E i mobili? Me lo chiede?', *Rassegna*, No. 3, pp. 15-16. Milan, July 1980.

7. Now in id., *Escritos II*, cit., p. 268.

8. A full plate in the album *Le Corbusier & Jeanneret II*, *L'Architecture Vivante*, plate 11. Paris: Albert Moracé, 1928, and a full page in volume 1 of the *Oeuvre complète* in 1929.

9. One of these Matisse paintings, *Studio with Goldfish*, from 1912, had appeared in a print in *L'Esprit Nouveau*, No. 22. Paris: Crès, April 1924.

10. Le Corbusier, *Vers une architecture*, p. 181. Paris: Crès, 1924 (2nd ed.).

11. Moholy-Nagy, László. *Malerei Fotografie Film*, Bauhausbücher 8. Munich: Langen, 1925 (2nd ed. 1927).

The Cross and the Wheel

12. See the two volumes covering the exhibition in the Museum of Fine Arts, Boston: Troyen, Carol, and Hirshler, Erica E., *Charles Sheeler: Paintings and Drawings*, and Stebbins, Theodore. E., and Keynes Jr., Norman, *Charles Sheeler: The Photographs*. Boston: A New York Graphic Society

Book, Little, Brown and Co., 1987, and also Lucic, Karen, *Charles Sheeler and the Cult of the Machine*, London: Reaktion Books, 1991.

13. As Weston wrote in his diary in 1922. See *Charles Sheeler: The Photographs*, cit., p. 21; for Weston's diaries: *The Daybooks of Edward Weston*, 2 vols., edited by Newhall, Nancy. New York: George Eastman House, Horizon Press, Rochester, 1961 and 1966.

14. A lucid contemporary vision of the assembly line in Kisch, E.E. *Paradies Amerika*, Berlin: Erich Reiss, 1930. See also: Lahuerta, Juan José. *1927. La abstracción necesaria*. Barcelona: Anthropos, 1989.

15. Zayas, Marius de. 'Photography', *Camera Work*, XLI, January 1913, p. 17 and 'The Evolution of Form', id., pp. 44-48.

16. Jolas, Eugène. *transition*, No. 18, p. 123. Paris, Autumn 1929.

17. Renger-Patzsch, Albert. *Die Welt ist schön*. Munich: Kurt Wolf, 1928.

18. *Ford News*. Dearborn, Michigan: Ford Motor Company, 15 February 1929. Among others, 'Storage Bins at the Boat Slip' had been used on the front cover of the issue of 1 May 1929.

19. 'By Their Works Ye Shall Know Them', *Vanity Fair*, No. 29, p. 62. Greenwich, CT: Condé Nast, February 1928.

20. Rourke, Constance. *Charles Sheeler: Artist in the American Tradition*, p. 130.

New York: Harcourt, Brace and Company, 1938.

21. Loeb, Harold. 'The Mysticism of Money', *Broom*, vol. 3, No. 2, pp. 115-130. Rome, September 1922.

22. See: Merback, Mitchell. *The Thief, the Cross and the Wheel*. Chicago: The University of Chicago Press, and London: Reaktion Books, 1999.

22. Rosenblum, Naomi. 'The TAC Cover', in Stange, Maren ed., *Paul Strand. Essays on his Life and Work*, pp. 192-196. New York: Aperture Foundation, 1990.

23. Bataille, Georges. 'Cheminée d'usine', *Documents*, No.6, pp. 328-332. Paris, November 1929.

Lived Instant and Frozen Creature

ALBUM OF THE BARCELONA PAVILION / 1929

A comparison of the official photographs of the Barcelona Pavilion—taken by the Berliner Bild-Bericht agency, undoubtedly under Mies van der Rohe's personal supervision—with the more casual shots taken by reporters and amateurs can be highly instructive.

One issue is particularly striking: the system of selective erasure in the official photographs. A lot of things have disappeared from them: the doors, for example, which were taken off for the photographs, leaving only the marks of the hinges on the roof and floor; the concrete elements around the Pavilion, such as the adjacent buildings or the Ionic colonnade, whose ghost is intuited in these photographs only from its shadows; the signs advertising the firm that supplied the stone for the travertine pedestal; the pots of flowers that softened the Pavilion's arid abstraction with an unexpected touch of the Mediterranean patio; and, finally, people, utterly absent in the official photos and constantly present in the unofficial shots: a milling crowd in the press photos of the inauguration, more individualized and contemplative in the others. It is clear that the scale— in every sense—of the Pavilion changes with these presences, which multiply other—signs, pots, colonnade...—and enable us to appreciate the relativity with which the Pavilion's modernity was perceived by the popular press of the time.

Closing the circle, we might note yet other disappearances: in the photographs of the opening day, in addition to Mies van der Rohe, fidgeting somewhat awkwardly with his gloves and hat, the protagonists are King Alfonso XIII and the general commissioner of the German delegation, Georg von Schnitzler: the former was deposed less than two years later with the proclamation of the Spanish Republic on April 14, 1931; the latter, a chairman of the IG Chemical Industries Farben, Nazi sympathizer and party member from 1937, was later tried for war crimes and sentenced to imprisonment. Finally, the Pavilion itself was destroyed forever in early 1930, having served its purpose.

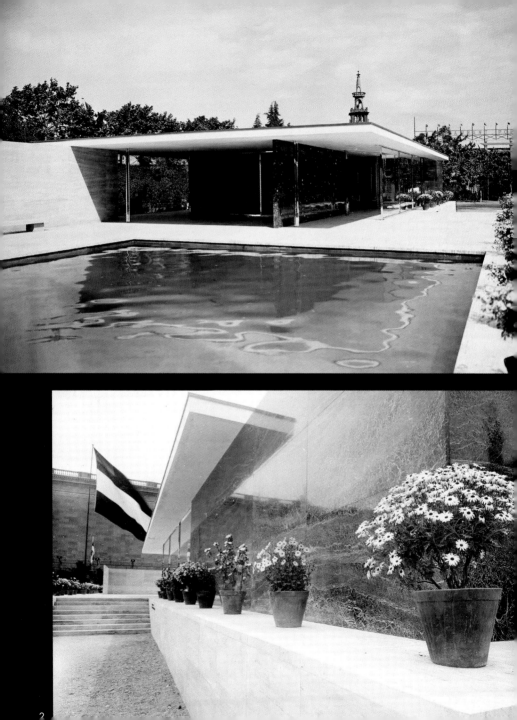

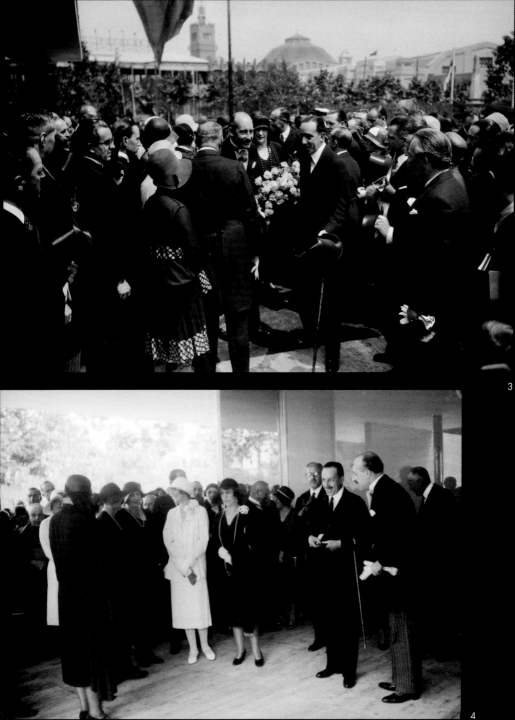

3

4

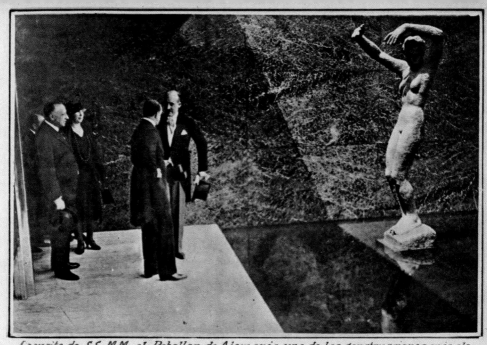

La visita de S.S. M.M. al Pabellón de Alemania, una de las construcciones más elogiadas del Certamen. — Un rincón del Pabellón. — (Foto Maymó.)

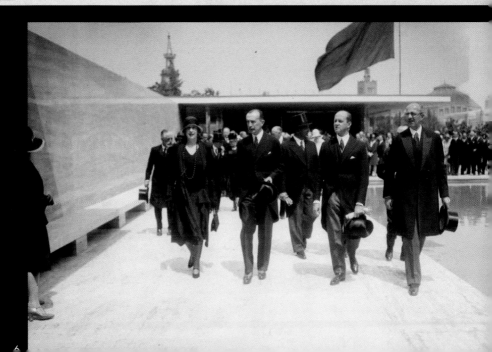

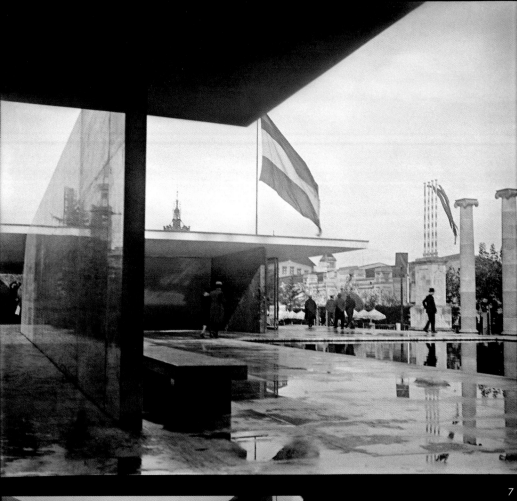

7

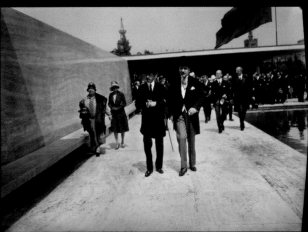

8

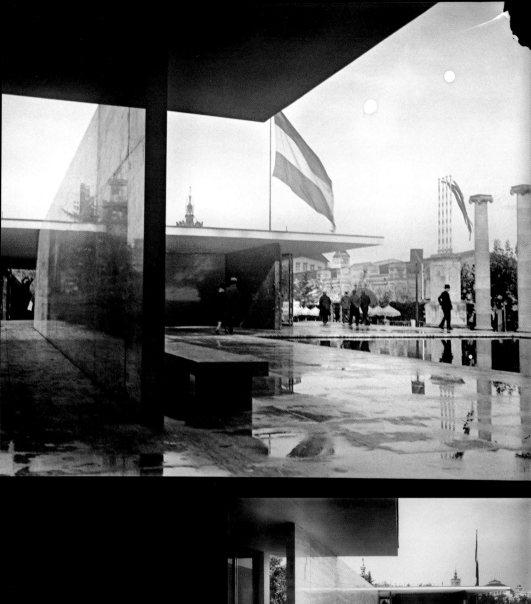

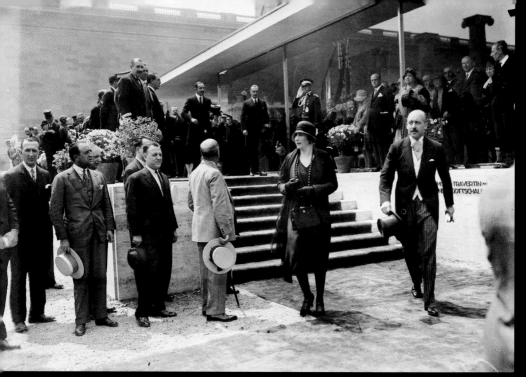

10

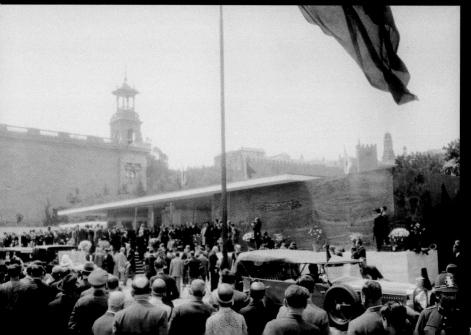

11

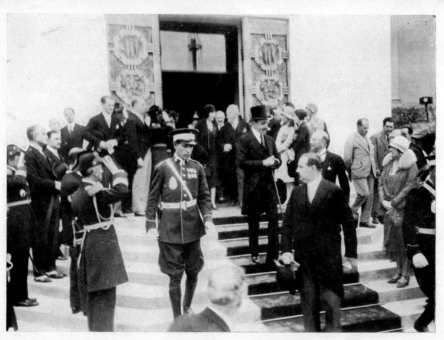

SS. MM. al salir del acto inaugural del pabellón de Francia.

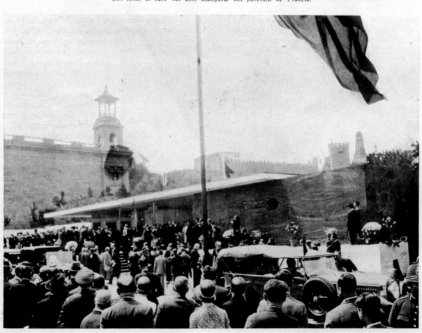

El pabellón de Alemania el día de su inauguración oficial.

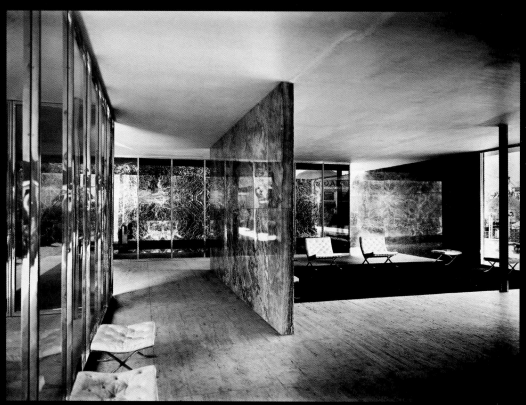

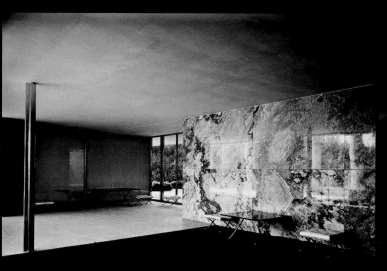

En la Plaza de las Bellas Artes, junto a la Avenida de Rius y Taulet, álzase el Pabellón de Alemania, de arquitectura modernísima y atrevida, espléndida muestra de las geniales osadías a que hoy se lanzan los constructores de edificios en aquel país.

De líneas sobrias y severas, de elegante uniformidad e impresionante estructura, es una bella muestra de los magníficos elementos decorativos y materiales de construcción de que hoy dispone la república germánica. Una visión más certera en este aspecto, no podía lograrse. El pabellón alemán es inconfundible; no puede ser más que alemán. Los mármoles, los desproporcionados cristales y la soberbia metalistería de que se compone este pabellón atraen irresistiblemente la curiosidad del visitante, por la disposición realmente maestra que se ha sabido darles. Quien haya admirado esta obra de la arquitectura moderna, no podrá ya olvidarla.

En las demás aportaciones de esta nación a nuestro certámen, que abarcan casi todas las secciones internacionales, es donde puede apreciarse su sorprendente adelanto que la gran guerra no pudo estancar, ya que sus ingenieros, sus arquitectos, sus fabricantes, sus artistas, mientras en el frente la lucha se proseguía implacable y cruel, estudiaban y producían, aguardando el momento en que, libres sus fronteras, pudieran de nuevo asombrar al mundo con su admirable potencialidad.

La industria automovilista muestra verdaderas bellezas, entre ellas un coche estilizado, cuyas líneas apenas resaltan. Un ave de acero que parece revestida de plumajes. La sirena es una demostración de elegante futurismo y su decoración en laca, de un efecto muy bello y sorprendente.

Disciplina, laboriosidad, ingenio, he aquí el tríptico sobre el que reposa la impresión que produce la vista del Palacio de Alemania, la nación que triunfa en todas las esferas industriales y cuya exportación alcanza cifras gigantescas, merced al abnegado esfuerzo de sus hijos.

Las exhibiciones de sus productos pueden admirarse en las secciones correspondientes de los grandes Palacios de la Exposición. Descuellan entre estas las que han sido instaladas en el departamento de Maquinaria del Palacio de la Electricidad, Fuerza Motriz e Industrias Químicas. Allí es donde el visitante puede darse cuenta de las magníficas máquinas que la industria de aquel país produce, destinadas a los más diversos usos. Ya sabemos hasta qué punto de perfección ha llegado Alemania en lo que a electricidad se refiere. Los "Stands" que presenta el Pabellón alemán de Electricidad son una prueba patente de ello.

No les van en zaga, sin embargo las instalaciones del Palacio de

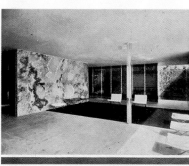

Comunicaciones, donde se exponen los más modernos modelos de automóviles y aviones últimamente lanzados al mercado. Y tambien son dignos de admiración las del Palacio de Proyecciones por lo que a la cinematografía, fotografía y óptica se refiere. Mas lo verdaderamente remarcable, a nuestro juicio, es lo que existe en el Palacio de Artes Gráficas. Alemania que presenta en dicho local máquinas de imprimir papeles diversos y de una variada selección de las más bellas muestras del arte editorial contemporáneo, demuestra que no en vano es la cuna de Guttenberg, cuyo invento ha sido llevado en ella a los mayores perfeccionamientos.

En el Palacio de Industrias Textiles rama en que Alemania tiene una preponderancia indiscutible, se ha puesto de manifiesto los últimos adelantos de su fabricación. Muy notable es, también, la exhibición de juguetería, sita en el Palacio de Artes Decorativas e Industriales, donde se hallan tambien expuestos instrumentos de música.

Finalmente, los Palacios Meridional y de Agricultura muestran tambien interesantes aspectos de la producción alemana, principalmente en este último la cervecería y las máquinas agrícolas.

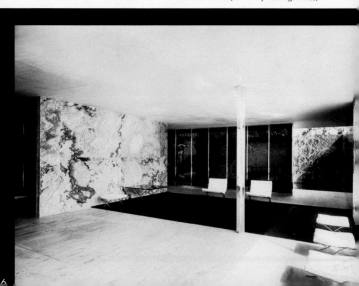

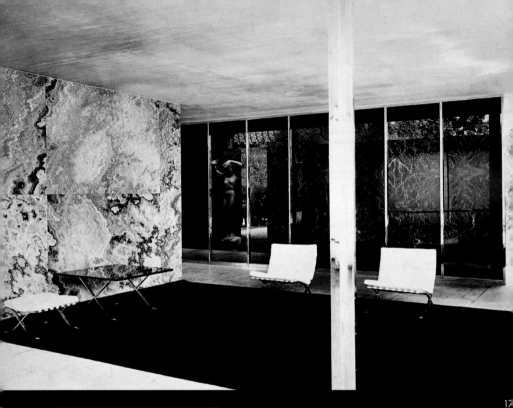

17

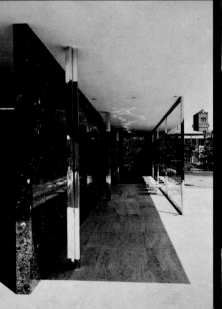
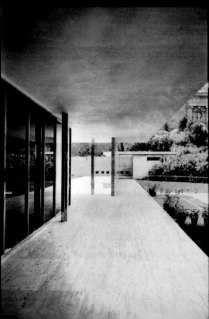

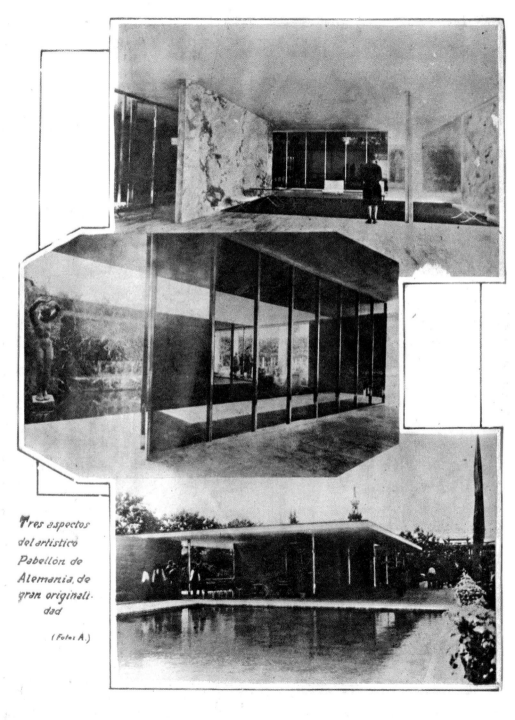

Tres aspectos del artístico Pabellón de Alemania, de gran originalidad

(Fotos A.)

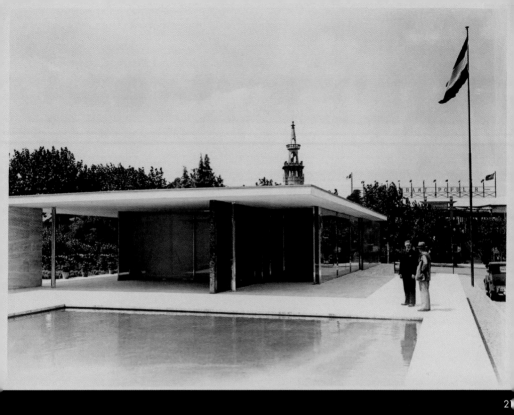

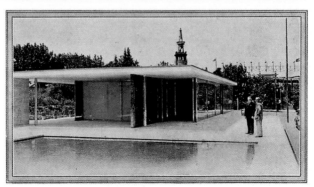

El pavelló oficial alemany, construït amb una gran austeritat de línies i amb una extraordinària riquesa de materials, és un dels que més impressionen. Marbre, cristall, níquel; una il·luminació indirecta. En un dels departaments d'aquest pavelló hi ha la peça d'aigua que publiquem en una altra banda d'aquest extraordinari. Una escultura que la decora és l'única nota viva en mig de les línies severes

EL PABELLON DE ALEMANIA

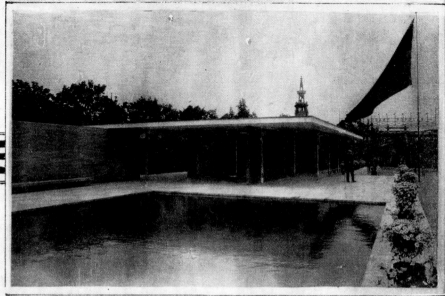

Sencillo, geométrico aparece el Pabellón alemán con una extraordinaria modernidad.

EL PABELLON DE SUECIA

*Las líneas del Pabellón sueco recogen toda la fuerte sencillez
del gran pueblo del Norte.*

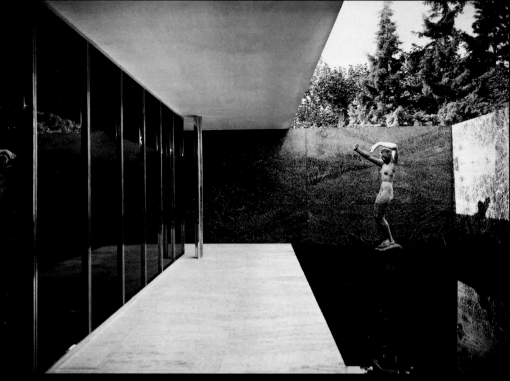

24

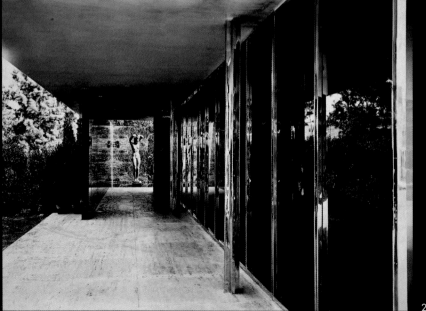

25

26 ›

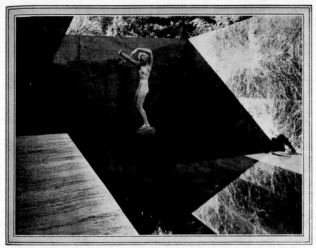

Un aspecte del Pavelló alemany. Un estany entre marbres foscos i una estàtua en marbre blanc que s'hi reflecteix

Aquesta indispensable condimentació de modernitat no és aconseguida, però, per obra i gràcia de les soles florasses de vidre i llum, sinó també per l'arquitectura, la petita arquitectura dels pavellonets isolats i escampats per les frondes de l'Exposició; també per alguns pavellons nacionals així mateix destacats entremig de la jardineria o arrenglerats en allò que hauria pogut ésser la nostra *Rue des Nations:* el ric, encara que no molt bell pavelló d'Itàlia, que en riquesa no té parió a l'Exposició actual; el d'Alemanya, molt ric també, però excessivament simple; el de Iugoslàvia, obra de fusta, massa original; el de Dinamarca, típic, probablement lleig, però tan graciós; el d'Hongria, probablement també lleig, però solemnialment atrevit; el de Romania, lleig, bàrbar i pagerol com tot l'art popular d'aquestes terres eslaves; el pavelló del subministre elèctric d'Alemanya, tan indigent com el pavelló nacional d'aquest país, però fet amb materials pobres; el de França, que és un dels més dignes; el simplicíssim, obrat en fusta, que bastí Suècia.

Després cal esmentar la nova arquitectura dels petits pavellons particulars; el dels artistes reunits, que encara no està obert; el de la Confederació Hidrogràfica de l'Ebre, també en via d'acabament, com el de la Companyia d'assegurances italiana que Millàs Raurell impulsa perfectament; les torres de l'aero-rotor Savonius, del ciment Asland i dels magatzems Jorba; els pavellons de la Hispano-Suïssa i de la Companyia Asturiana de Mines, i molts d'altres. De tota aquesta petita o gran arquitectura que malda per modernitzar-se, ens sembla més reeixida la que en lloc de rompre totalment amb la tradició s'hi alia, com és el cos de la torre prismàtica quadrada que s'aixeca sobre volta a mà esquerra de l'entrada de l'Exposició. També les dues torres d'entrada ens semblen una feliç adaptació del *Campanile* de Venècia. Itàlia també reïx, encara que no siga amb molt bon gust, en reestilitzar diversos elements arquitectònics

clàssics i fer-ne, a la manera de Ginoví, un gros bibelot per a la vitrina del feixisme. En canvi, la font de la Plaça d'Espanya ens sembla una grossa equivocació.

Una vegada sentades aquestes generalitats, anem a la ventura en cerca d'aquesta petita quantitat d'art decoratiu modern escampat per tots els recons de la vasta àrea de l'Exposició. En dir *modern* entenem senyalar l'art decoratiu que vol renovar: només excepcionalment, i per raó de la seva perfecció, cridarem l'atenció sobre l'aportació de les signatures principals de reproducció o continuació dels estils clàssics, perquè, per a nosaltres, hi ha més mèrit, es demostra més sensibilitat, i en definitiva es rep més delectació en la cabal interpretació dels subtils i refinadíssims estils clàssics que en les brutals simplificacions de l'art més exageradament innovador.

Cal remarcar la unitat que en aquest estil exageradament innovador ha imposat Alemanya a totes les seves instal·lacions, a totes les seves arquitectures. És el més anguniós pesombre de

l'Exposició. Un atenuant és la riquesa de materials: per raó d'aquest truc que sempre serà lloable, l'angúnia no mata, i als esperits impacients ajudarà a adorar amb fe d'evidència aquestes formes de munició.

En l'allau d'instal·lacions poca-soltes o miserables que empleven el Palau de la Metal·lúrgia, ens sobta el stand enginyós i tan poderosament atraient de la Metalúrgica Roses, S. A.: amb només claus i puntes de París, el projectista ha fet una sorprenent instal·lació. En el Palau de Projeccions, la sala d'espectacles és el millor de tota aquella estimable arquitectura readaptada del gust tradicional al modern. En el Palau dels Teixits, que és un dels indrets de l'Exposició on abunden més les pensades idiòtiques, destaquen per llur bon gust les instal·lacions col·lectives dels fabricants de Terrassa i de Sabadell. La dels sabadellencs es fa admirar també per la seva modernitat graciosa: els plafons de mosaic de drap de llana són una deliciosa troballa i una realització mestrívola. La instal·lació alemanya d'aquest palau, no tan indigesta com la d'altres seccions germàniques, val per la riquesa de materials i per alguna diversitat introduïda a l'estil antisèptic.

Entrem ara a un dels dos palaus construïts per Puig i Cadafalch: el de mà dreta. Immediatament trobem la instal·lació variada dels austríacs: la llotja de les cerimònies oficials ja és una bona mostra de bon gust vienès; l'aliança de l'art nou i de l'art antic hi té aquell picant de refinament decadentista que els millors decoradors alemanys i suecs, que l'italià Ginoví han fet seus. Entre les nombroses petites instal·lacions remarquen la dels tallers de bisuteria diversa que exhibeixen argenteria, marroquineria, teixits, ceràmica, etc., etc., sobresurten la Wiener Werkstätte i l'Österreichischer Werkbund. En la catifèria no hi ha res millor que la Knüpfteppichindustrie System Banyai. No sabríem dir quina és la peculiaritat d'aquest sistema Banyai: les catifes de la K. S. B. semblen de punt nuat com les de tot arreu. Curiós també el stand de papers d'emparerar de la Wiener Tapatev Fabrik. La fàbrica de ceràmica artística de Liezen (Estíria) és admirable per la seva perfecció i riquesa de color; és seductora pel gruix saborós de les peces i per l'originalitat de les formes: és pisa de vitrina. Gairebé tota la moderna pisa austríaca de vitrina, les figures i animals sobretot, és d'una condició inspirada en la més barroera pisa popular. Els nous ceramistes vienesos han pres aquesta ingènua barroeria com un punt de partida: han reestil-

El Pavelló de Suècia tot construït en fusta pintada de blanc

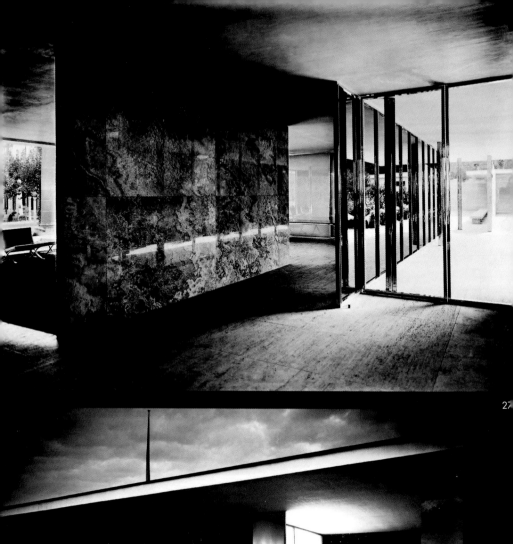

27

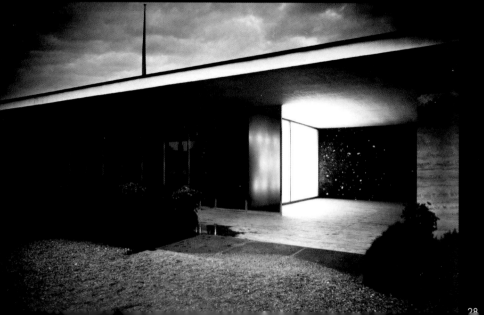

28

POPULAR MIES

Let's focus our attention on two of the photomontages of the Friedrichstraße skyscraper [fig. 47, 48]. What is the building by Mies here? To describe it we could employ all the usual metaphors: a gigantic keel, the menacing blade of an enormous knife, a scalpel... In fact, though, looking at these two images, we have the impression that it would be possible to order them as a process of darkening. In the first of the two photomontages, in the order we are supposing, we can clearly distinguish the jointing of the paving, a number of stalls and kiosks on the pavement and, on the right, perfectly clearly, the buildings with their shops, shop windows, signboards and neon, their floors ordered in the classic grid of windows and balconies, their mouldings, pediments, finials, domes... and also the people circulating on this wintry street, most of whom, because of the long exposure time the photograph required, transformed into transparent silhouettes, scurrying phantoms; in the second, however, Mies's charcoal has been busy eclipsing pavement and buildings, turning them, especially the buildings, into a dark mass about to engulf all detail.

It is curious to note that ten years after Mies created these photomontages, Siegfried Kracauer wrote a piece on Friedrichstraße that seems in some ways to describe—or counter-describe—them.[1] When a powerful locomotive stops on the bridge that spans the street, its great mass of steel with its rows of red wheels literally suspended above the pavement, what, Kracauer asks, is the most amazing thing about this wonder? Precisely that no one is amazed. The passers-by, he writes, do not consider this sight worth even a fleeting glance. The 'impressions' that bombard them at 'ground level' are enough to hold—or capture—their already inconstant attention: 'cafés, shop windows, women, food vending machines, posters with cubic lettering, neon signs, policemen, buses, photographs of *variétés*, beggars...'. In the nervous life characteristic of the metropolis—and in

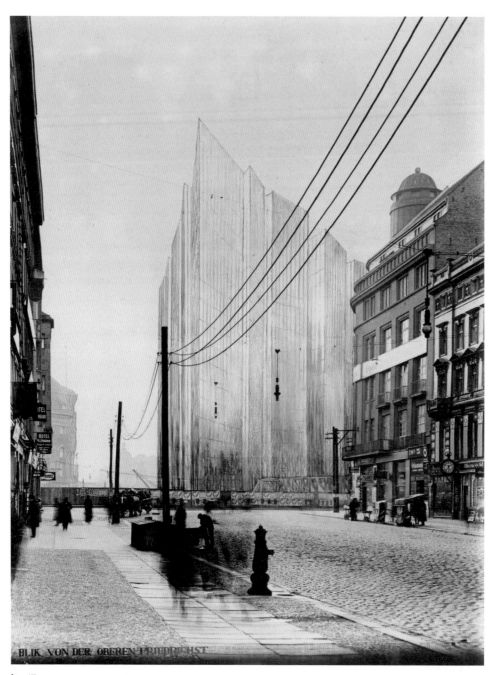

BLIK VON DER OBEREN FRIEDRICHST

fig. 47

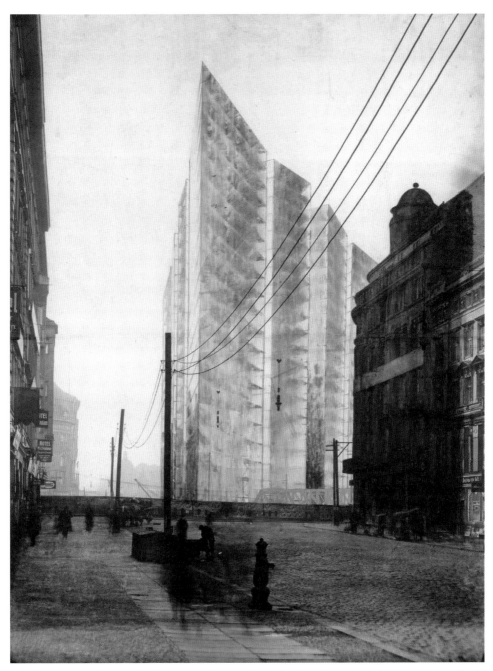

fig. 48

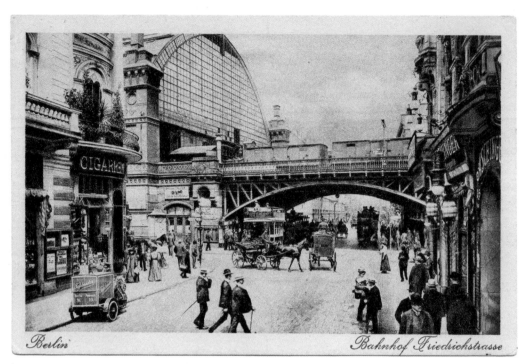

fig. 49

Kracauer's no less characteristic description—people have no time to look up, let alone to take a long look, so if the many tons of steel and the power divested of that tremendous estranged locomotive can make themselves invisible, what cannot happen—and this, for us, is the most interesting aspect of this description—to the buildings that line the street, with their façades above the shops? 'Even the mezzanines are volatilized on this street,' Kracauer writes, 'the caryatids that adorn the façades have no one to look them in the face, the glazed balconies could be of *papier maché*, the roofs are diluted into nothingness.' The locomotive, in short, is nothing but a 'stranger that penetrates the nocturnal gloom and suddenly vanishes, as unobserved as if it had always been there or was never there at all.'

We are not concerned here with how the article continues, describing, no doubt much more conventionally, the other view, from the bridge that crosses Friedrichstraße [fig. 49], seen by the driver and passengers of the train during the few moments that it stops there: the celebrated spectacle of the big city. We are more interested in the coincidences, and even more in the differences between this description and those manipulated photographs. Mies has chosen for his photomontages a wintry, misty photograph, somewhat faded, and in one version he has gone to the trouble, as we have seen, of darkening it even more, eliminating the details of the shops and advertisements: 'ground level' is where his charcoal has acted most densely. But what now cuts through the 'nocturnal gloom' is not the locomotive but the glass skyscraper, advancing from the right and rising up into the centre of the scenario, with its tremendous arris and its multiple facets. In the locomotive, everything is *power*, its immobility in the station *power* of its speed and its strength, its suspension on the bridge *power* of its weight, and so on. This being so, on the boulevard of the great city, amid the nervous life the city requires, in the 'delirium of letters of the alphabet on fire' of which Kracauer speaks, clearly echoing that other 'city of scrambled alphabets' described by John Dos Passos in *Manhattan Transfer*,[2] the locomotive's permanence, its fixity, even if only for the instant of its stop in the station, renders it invisible. The great engine pauses for a moment on that street, but does not belong to it: it is neither 'image' nor 'impression': with good cause the Impressionists painted the smoke and steam of the stations, but hardly ever the trains.[3]

Mies's skyscraper, however, moves from the right and rises up from below, to stay there like an iceberg run aground. In opposition to the *power* of the locomotive, here everything is *evident presence*. In contrast to the locomotive, it has come, at least in what these photomontages show, to attract attention *over and*

above the boulevard, not in its material or concrete details—the caryatids, the glazed balconies and the cornices it does not have—but in its reflections: 'the rich play of light reflections' that Mies himself mentioned in describing it in the project report he published in Issue 4 of Bruno Taut's magazine *Frühlicht*.[4]

'Impressions', then. Those produced 'at ground level', which are essentially, of course, of 'light'—shop fronts, cubic letters, neon signs, 'alphabet in flames'—are no longer left behind when people look up; on the contrary, they continue and multiply in the extraordinary height of the glass skyscraper, in a gigantic shower of sparks that condenses the whole *blaze* of the metropolis's signs. Mies now offers the *abandoned eye* of the crowds the greatest occasion of *distracted attention*: the reflection as the quintessence of modernity, where everything, as in advertising, which is its first principle and its ultimate goal, is always new and always the same. His skyscraper, unlike the locomotive, will be ostensibly visible, supervisible, like the advertisements on the street, and, logically, the more evident the skyscraper becomes, the darker the façades of Friedrichstraße, and of the whole city. This process concludes definitively with a large charcoal drawing made from the same point of view as the photomontages, in which any incident that takes place in the street, every element—pavements, kiosks, buildings, people...—has now disappeared once and for all [fig. 50]. The pavement and façades are no more than a black U-shaped continuity: Friedrichstraße has turned into a kind of deep mineral incision; an orthogonal cut in a coal mine. Just as the street on the left hurries away into the distance at full speed and slips with a sigh through the narrow eye of the station bridge, so the skyscraper on the right rises to a point and advances towards us, deploying itself in its absolute evidentness.

The 'scalpel' that Mies has designed penetrates the amorphous black mass of a city old and new by condition and necessity. But there is more. In the 'step' of the first photomontage to the second, the glass façade of Mies's skyscraper has become a transparent skin, a luminous veil around the skeleton formed by very thin horizontal sheets of the floor slabs. The first reason is probably somewhat naive: in our first photomontage Mies represents the city by day and at night in the second. In the first, daylight is reflected in the glass sheets, which present themselves to our gaze as bright and opaque; in the second, as the façades of Friedrichstraße become darker, the skyscraper, thanks to its own illumination, lights up from within, and shows itself to us in even greater evidentness, if possible: that of its absolute transparency, that of its nakedness to the bone.

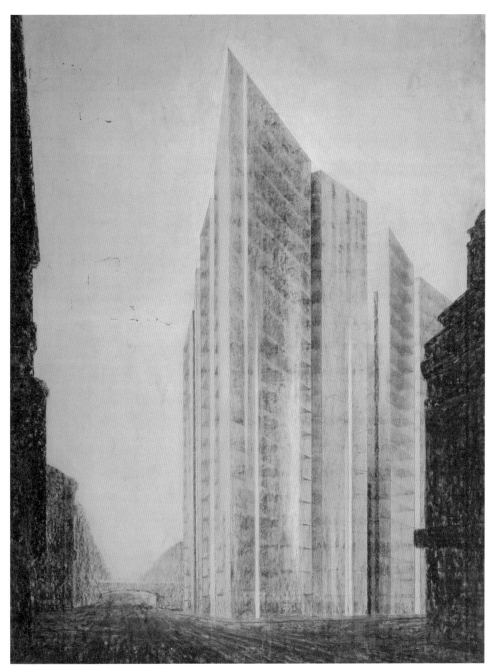

fig. 50

Now we understand the process even better: the more massive, dark and amorphous the city, necessarily nocturnal, the more crystalline, transparent and perfect the skyscraper. In the report we mentioned above Mies spoke, in fact, of 'an architecture of bones and skin' and from this point of view the skyscraper stands before us like a delicate skeleton wrapped in a spectral transparency. This is what happens, of course, in academic art education, which, as Alberti observed in *On Painting*, makes the determining principle of the form the skeleton, which is then clothed with muscles, skin and garments. At the same time, however, since we are in 1921, this is what happens in radiography, which, indeed, merely confirms by photographic evidence, by contact, what academic anatomy had always drawn: bones, muscles, veins and nerves, perfectly distinct and distinguishable, and very different from the shapeless mass of flesh and blood that the surgeon actually encounters in an operation.

But back to business, though we have not strayed far. Radiography, surgery and the scalpel are the great metaphors contained in the image that Mies gives us of his glass skyscraper. Or, more precisely, in this apparition, quite sinister when we consider the point of view from which, thanks to the photograph used for photomontages, Mies obliges us to contemplate it, the angle maintained and aggravated in the drawing: we are in the middle of the darkness of the street, down there, in the mine, watching how from the right and upwards this building emerges, extremely sharp, hard, uncompromising, but seeing too, and this is even more important, that it is absolutely empty. The bones and the skin have become the ghost and the skeleton of the modern city. We could say that our times emerge from that building hypnotized, phantasmagorical and stripped of flesh. Mies's photomontage seems to be the epiphany of that terrible period: Germany in the early twenties. But it is also the nest or the egg of the serpent of our own times: the modern Magi would have the entire twentieth century—up to the year 2001—to adore opaque and transparent skyscrapers of steel and glass.

That said, could we not place these questions in a different light? Speaking of light, as we have been all along, we can start with the radiographic view. Beatriz Colomina has referred to 'Architecture and X-rays', in a recent essay, and has rightly done so under the sign of terror and the control that modernity imposes and exercises on individuals.[5] I, however, would like to recall here another question not unrelated to the previous one, certainly prior, but now almost completely forgotten: that of the tremendous popular enthusiasm for X-rays in the early years of the twentieth century, ever since Wilhelm Röntgen discovered them late

in 1895, fixing on a photographic plate the skeletal image of his wife Anna Bertha's left hand, the shadow of a wedding band circling her ring finger, first published in *Neue Freie Presse*, precisely, on January 5 1896, the eve of Epiphany, and immediately thereafter in newspapers, magazines and books around the world [fig. 51].

Before their medical applications had been developed [fig. 52], X-rays had become fairground attractions and an entertainment for the masses: public demonstrations of X-rays, where people could view the living skeletons of their own hands—the super articulated hand was the most popular subject—on coin-operated machines, shared time and booths with another closely contemporary discovery, no less phantasmal and almost as funereal: the cinema. When, in April 1896, Edison showed his great invention, the fluoroscope, the 'portable' X-ray machine, he did so not at a scientific meeting but at the Electrical Exhibition in New York's Grand Central Palace, in front of hundreds of curious onlookers. Radiography progressed from the fairground to the home, as a toy and a family pastime, just as magic lanterns and stereoscopic photographs had done a few years before: we will consider these below. For example, a cathode ray tube was a fairly affordable after-dinner amusement, allowing people to look at the skeletons of their own and their friends' hands, and it was all the rage to have an X-ray photograph among the various portraits of oneself. The sensationalist press, cheap novels and the cinema (with films that were more or less frightening and more or less funny) popularized the new invention, along with its wilder applications, as advertised in the pages of newspapers and magazines the world over: X-ray devices to see through women's clothes, X-ray hair removal and so on, and although terrible 'side effects' soon began to be evident, radiography remained extraordinarily popular in the nineteen twenties and even in the thirties.

People had become accustomed to seeing slides of bones, sometimes used ironically, in newspaper cartoons, sometimes heroically, in the experiments of the avant-garde, whose photo-books always included X-ray images. As a man remarks at the beginning of the book by Bettyann Holtzmann Kevles: 'That reminds me of Berlin in 1936. My mother used to take me to a shoe store where I put my feet under a fluoroscope to watch my bones.'[6] Children were entertained by apparatus of this kind in shoe shops in many parts of the world, but, speaking of Germany, why not recall something much more delicate and at least as penetrating as that sheet of glass? Surely not coincidentally, in the same years that Mies was making photomontages of his skyscrapers, Thomas Mann was completing *The Magic Mountain*, which he had begun much earlier, in 1912, as a short story that was to have been

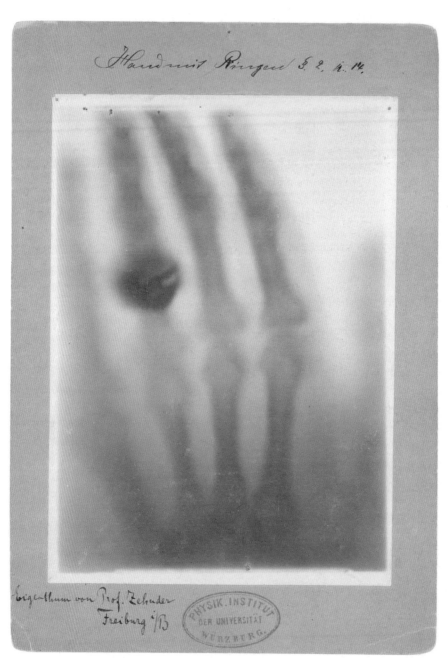

Handmit Ringen 3 2. h. 14.

Eigenthum von Prof. Zehnder
Freiburg i/B

PHYSIK. INSTITUT
DER UNIVERSITÄT
WÜRZBURG.

fig. 51

fig. 52

Tab. 133

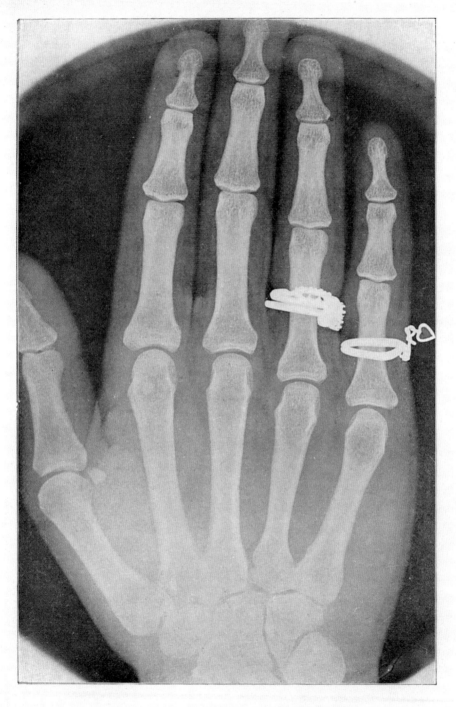

the humorous counterweight to *Death in Venice*, and thus a kind of *divertimento*, which, in view of its sombre mood, is significant; Mann returned to it in 1920, and finally published it as two fat volumes in 1924.[7] 'It was meant,' Mann said in 1936, 'as a humorous companion piece to *Death in Venice* [...] a sort of satire on the tragedy just finished. The atmosphere was to be that strange mixture of death and lightheadedness [...]. *Death in Venice* portrays the fascination of the death idea, the triumph of drunken disorder over the forces of a life consecrated to rule and discipline. In *The Magic Mountain* the same theme was to be humorously treated. There was to be a simple-minded hero, in conflict between bourgeois decorum and macabre adventure.'[8]

When we hear about this specific humorous vein—the comical conflict resolved in the macabre, the 'mixture of death and lightheadedness'—what comes to mind is surely the essence of the most popular comic horror, the cinematic, that of slapstick, where ghosts appear, skeletons dance and bodies are constantly being dismembered and disintegrating, only to put themselves back together in the next scene as if nothing happened and start over in a continuous comic death, funny and painless, indeed, that prepares us for modern life, in which everything also starts over again as new, but always the same. In fact, the story of *The Magic Mountain* takes place 'back then, long ago, in the old days of the world before the Great War, with whose beginning so many things began whose beginnings, it seems, have not yet ceased.'[9]

But of all the infinite gradations explored by this extraordinary novel, one in particular interests us now, precisely because it is the one that best fits with everything most fully determined by the *popular mechanism* of its story, and precisely what unites the macabre with the comical aspects of sickness and death: the absolutely central role of radiography.

In the sanatorium, Hans Castorp, our hero of modern life, falls head over heels for Clavdia, a woman utterly out of his reach, and unable to have any memento of her, he steals from the Director's file cabinet the X-ray plate of her lungs. He carries it around in his pocket, and looks at it from time to time with the emotion of someone contemplating a portrait of a lover: 'the portrait of Clavdia's interior, without a face, but revealing the organs of her chest cavity and the tender framework of her upper body, delicately surrounded by the soft, ghostlike forms of her flesh.'[10]

X-rays are constantly described in such terms in *The Magic Mountain*—Hans's own, his cousin's, Clavdia's...—as graceful, exactly drawn bones, as 'frames', 'supports', 'braces', 'scaffolding structures' or 'constructions' exemplifying the 'functional use of mechanical materials'—pillars, beams, rods, bolts, cables, cranes—wrapped in fine veils, haloes 'soft' and 'pale', 'a foggy halo of flesh', translucent gauze, silhouettes or 'ghostlike' transparencies. This contrast, which Mann describes on many occasions, and which ends up creating a strange general atmosphere (the air in the sanatorium is almost always charged with sort of diluted ozone),[11] would certainly suffice to situate the radiographic views of Mies's skyscraper in a vast cultural system in which technology, entertainment, terror and death mutually amplify each other. Radiography as a perfected, individualized and reflective form of the phantasmagorias of the past is part of the great spectacle that the crowd needs to contemplate itself as such. But that is not all. Radiography makes what was opaque transparent, and reveals the interior of what has hitherto been hidden, but in fact it does so at the cost of a tremendous simplification: as I said before, the confused mass of flesh and blood is transformed into this subtle, vaporous, radiant gauze around the bones, everything in black and white, contemplated in a translucent glass photographic plate. The way in which the human body becomes transparent and abstract, transformed into a subtle range of shades of grey between black and white, light and shade, always with the hard, opaque reference of the skeleton, is exactly the same as what we see in the drawings of the glass skyscraper: 'architecture of bones and skin', but sharp bones, without a scrap of flesh—at most, perhaps, a foggy halo, but in Mies not even that—and skin that dissolves in the faintest trace of radiation.

We have seen how the contrast between structure and enclosure corresponds to the academic tradition of starting to paint the body with the skeleton, then the flesh and skin and last of all the clothes. Radiography, in this sense, could not be more familiar to an architect. However, what radiography does, as Mies himself did, is to take this principle to extreme heights of abstraction, attained—and this is essential—through the guarantee of technology: is it not both familiar and strange that a machine should show us the bones of our living hand? Freud, we know, called this sudden shift from the familiar to the strange the uncanny. Thomas Mann makes the room where 'intimate photographs' are taken the source of the 'funereal photograph'.[12] When Hans Castorp looked at his own X-ray, Mann writes, 'he saw his own grave. Under that light, he saw the process of corruption anticipated, saw the flesh in which he moved decomposed, expunged, dissolved into airy nothingness—and inside was the delicately turned skeleton [...]

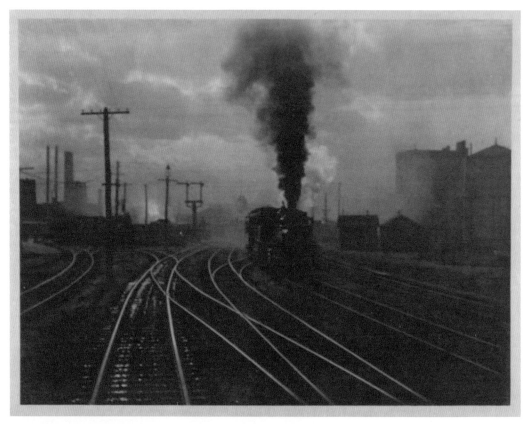

fig. 53

 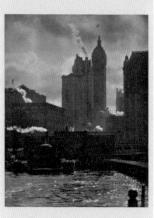

fig. 54, 55

and for the first time in his life he understood that he would die.'[13] In the perspectives of his Friedrichstraße skyscraper Mies pared this vision further still, and even the recollection of the *memento mori*—pun intended—that startles Hans Castorp has been abolished, since 'that light' no longer shows even 'a foggy halo of flesh' around the structural bone, the stripped anatomy.

If we translate Hans Castorp's reflections to the images of the skyscraper, what grave are we looking into? What are we seeing 'for the first time' if not the effects of the bombing to which the glass skyscrapers are destined? The calming words with which Dr Behrens reassures his patient about the X-rays could be applied to Mies's skyscraper: 'You may set your mind at ease—our procedures are quite aesthetic...'.[14] Nothing else could be expected from that *popular* 'illuminated anatomy':[15] phantasmagoria, magic lantern, X-rays, cinema. That is the culture from which the photomontages and drawings of the Friedrichstraße skyscraper emerge, technology and spectacle to entertain and terrify.

But enough of X-rays. Let's look once again at how both the city and the skyscraper are shown in Mies's photomontages and drawing. We have already remarked on this: an overcast nocturnal city, a skyscraper cutting into it like a keel. What does this schematic description reminds us of but the way in which the photographers associated with Alfred Stieglitz and *Camera Work* [fig. 54] represented Manhattan and its skyscrapers?

From the early years of the twentieth century, photographers like Stieglitz himself, Alvin Langdon Coburn and Edward J. Steichen busied themselves in applying the techniques and style of so-called pictorialism—the habitual manner, of course, of the amateur—not to what had hitherto been the customary subjects— cloud formations, sunrises and sunsets, mountains in the fog, backlit landscapes, twisted trees and more or less out-of-focus portraits—but to the representation of the quintessential modern city: New York. But what can the 'nature' photography that characterizes pictorialism do, when applied to the big city, but necessarily interpret it as an 'other' nature? It is surely no surprise that something similar should have occurred in New York avant-garde circles in the early twentieth century, largely dominated by poets like William Carlos Williams, in which the need to affirm a distinct and distinctive aesthetic, the need for an American *celebration*, found one of its heroic realms in the conversion of Manhattan into an 'other' nature, precisely, all the more exciting and potent for having been constructed by the efforts and ambitions of men.

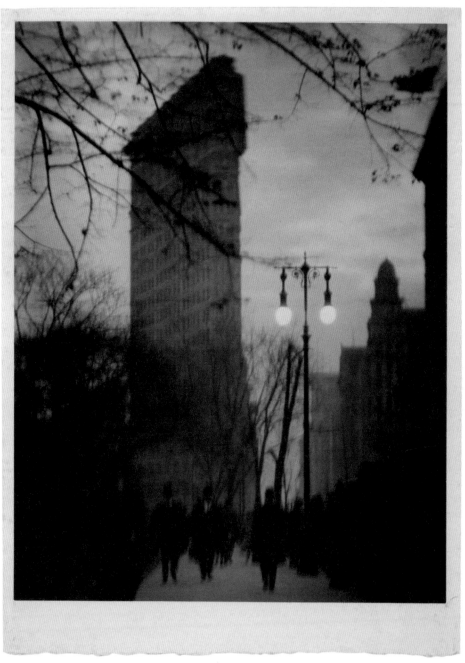

fig. 56

fig. 57

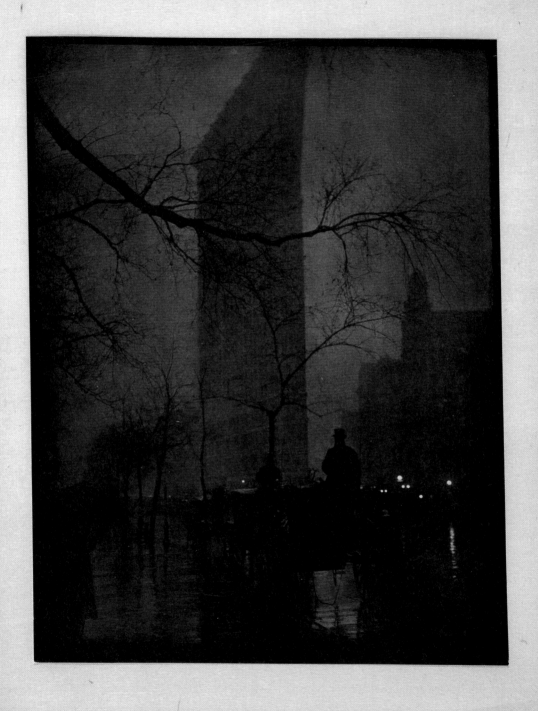

fig. 58

In 1917, in *The Blindman*, Henri-Pierre Roché championed the spirit of Walt Whitman as guide to the American Independents,[16] and a little later, in 1921, Paul Strand and Charles Sheeler—both associated, like Williams, with *Camera Work*—set the beat of their film *Manhatta* with lines from the exalted verses Whitman dedicated to his city in the eighteen eighties, in which the machines, buildings, bridges, trains, ships, iron, rocks and crowds that populate the city are mixed epically and thus over and above the terrible conflicts fought out in the city, presenting it as a single mass in organic, synthetic, painless continuity. New York is the most powerful nature, always in process of formation, and the crowds that populate it configure it as a giant sculpture crowned without contradiction by its machines, its bridges and its skyscrapers.

Camera Work was launched in 1903 [fig. 54], and by 1910 its images of Manhattan had reached perfection. The titles of Stieglitz's photographs, meanwhile, speak for themselves, from *The Hand of Man* [fig. 53] in 1902—a hazy railway yard bristling with telegraph poles, on whose shining tracks a smoking locomotive advances towards us—to *The City of Ambitions* [fig. 55] in 1910—the backlit crepuscular silhouette of Lower Manhattan's steaming skyscrapers rising above a river dotted with glittering reflections, criss-crossed by also steaming ferries. Machines and skyscrapers amid the steam and smoke they produce, a predilection for dusk or dawn, for winter, for rain or snow: these are the elements of the representation of this city's *perpetuum mobile,* especially in the general scenic views, in which the characteristic New York skyline, *magic mountain*, is defined for the first time: in the aforementioned *The City of Ambitions* [fig. 55], or in *Lower Manhattan* or *City Across the River*, all by Stieglitz, as in *Over the House-Tops. New York* by William E. Wilmerding, or *New York*—just so—by Coburn.

But at ground level too, pictorialism, applied to the urban landscape with a commitment that can only be described as a genuine and urgently felt 'will to style', performs its transformative mission: on one hand in the blurring of details, in the fading of contours, and on the other in the preference, yet again, for dusk/dawn and for winter, for fog or rain, it ends up constructing a very precise image of New York, necessarily misty and nocturnal, which periodicals and films transmitted to the popular imagination as the dominant image. The application of pictorialism's techniques and aesthetics to the supremely modern city—which, just to confuse things, is also the most lacking in qualities such as antiquity, in monuments, and so on—is revealed as an absolutely conscious project, and this is what is most relevant to us here: out of the mists of these

photographs, among those reflections, against the light, and that darkness, its true protagonists emerge: skyscrapers, surging forward in their menacing size and their unexpected scale.

Of all the skyscrapers of New York, the photographers' favourite is the Flatiron Building, completed by Daniel Burnham in 1902, on the triangular lot at the intersection of Fifth Avenue and Broadway, facing Madison Square, the most photogenic precisely because of its unique cutting shape, like a keel or wedge, the perfect image of the building advancing on the city. In a Stieglitz photograph [fig. 58] published in *Camera Work* in 1903, the slightly undulating shade of a winter tree intersects the straight edge of the Flatiron which appears in the background, looming up on the left through the mist of a snowy day; another Steichen image [fig. 57], also published in *Camera Work* in 1906: winter, night, rain, the streetlights reflected on the shiny pavement, in the foreground the silhouettes of people and the bare filamentous branches of the trees, while from the background, diffused in the mist, its crown cut off by the upper edge of the photograph, the keel of the great Flatiron block thrusts forward; another [fig. 56], by Coburn: in the winter twilight, the streetlamps lit, the passers-by blurred, the mesh of bare branches, and in the background, advancing and rising to dissolve in the mist, the backlit mass of the Flatiron. There is no need to go on. The keel of the Flatiron, in which the very form of the island of Manhattan itself resonates, is a powerful image, repeated time and again both in quality photographs like those in the books and travel albums of European architects in New York—see, without looking any further, the books and photos by Berlage [fig. 60], by Gropius or Mendelsohn—and, indeed, in popular photographs [fig.59]. A cursory look at postcards and souvenir albums of the city suffices for us to see the Flatiron, photographed almost always from a central viewpoint, facing the edge of the wedge, half way up its height, rising like a fine blade, perfectly sharp, on the vertex formed by Fifth Avenue and Broadway, which retreat into the distance like two limpid cuts in the mass of a city we contemplate in bird's-eye view. Without failing to exploit the dynamism this form, Stieglitz, Coburn and Steichen all dramatized it: ground-level views, mist and darkness, ghostly apparition looming over us from the middle distance...

What happens when we place these photographs alongside the perspectives of the Friedrichstraße skyscraper? It is clear, and there could be little dispute about this, that Mies's photomontages and drawing arise out of the characteristic type of representation of German Expressionism, but perhaps sufficient attention has not been given to the influence—decisive, in my view— exerted by the

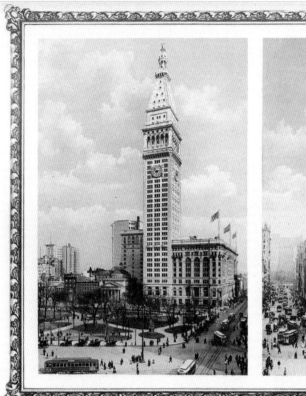

METROPOLITAN LIFE INSURANCE BUILDING, at 1 Madison Ave. Occupies the entire block to Fourth Ave. between 23rd and 24th Sts. A magnificent carved marble structure, the tower, facing 52 stories, 700 ft. high, constructed in 1910. (C) Geo. P. Hall & Son, N. Y.

FLAT-IRON BUILDING, which derived its name from its shape. On 23rd Street at the intersection of Broadway and 5th Avenue. 300 feet high, 120,000 sq. feet floor space. Cost including site, $4,000,000.

fig. 59

HET "STRIJKIJZERGEBOUW" No. 1

TE NEW YORK
BROADWAY AND 5TH AVENUE

fig. 60

MAQUETTE

MIES VAN DER ROHE
GRATTE-CIEL POUR LA CHICAGO TRIBUNE. 1923

L'ARCHITECTURE VIVANTE
AUTOMNE MCM XXV

'urban pictorialism' of the *Camera Work* circle on architects like Mies, and not just on their idea of the 'representation' of architecture but on the architecture as such, or rather, on how this imposed itself on the city: formally, ideologically. That veiled, nocturnal New York, in which the masses of the skyscrapers rise up, ghostly and aggressively, was, for them, one of the most powerful icons of the modern city, which was none other than the American city. I leave the question here, as a note. But I give notice that we will, inevitably, see *Camera Work* photographs again.

Let us look now at the other glass skyscraper by Mies, designed in 1922 as a prototype, with no client or commission—although, on the subject of Americanisms, it is surely curious, and significant, that the autumn-winter 1925 issue of *L'Architecture Vivante,* published two images of this project with the caption: 'skyscraper for the *Chicago Tribune,* 1923' [fig. 61].[17] In the photograph of the montage of the model which appeared that same year in *Frühlicht* [fig. 68]—illustrating, along with one of the photomontages of the Friedrichstraße skyscraper, Mies's first published article—we again see the structure of thin slabs and slender pillars through the transparent skin, as he wished. Indeed, he explains this in his text: skyscrapers are beautiful when they are in construction and show their skeleton, and the glass skin should arrest and preserve precisely that moment of affirmation of the structure as skeleton.

For one thing, in continuation, we should note here again the influence of the 'style' of the photos of New York skyscrapers under construction published in magazines like *Camera Work* and in the popular press on European architects, and on Mies first of all. There is no shortage of pictures of the metal structures of skyscrapers under construction, either in tourist guides and books on the progress of the city and the country as a whole, or—and this is clearly central to the popularity of these images—in the most commercial films: how can we forget the absurd adventures of Harold Lloyd's perilous clowning on these steel structures converted into machinery in motion in *Never Weaken* [fig. 62], from 1921, precisely?

But let's stay with the books: one popular title, taken at random from many others, John Foster Fraser's *America at Work* [fig. 63], first published in 1903, with numerous subsequent editions and translations, has the Flatiron still under construction on the cover, as the frontispiece and on its inner pages.

fig. 61

105

fig. 62

L'ossature métallique du « Flat Iron »

facture et reçoit l'argent. A un pupitre se tient une employée. Celle-ci vérifie la coupe et la facture, enveloppe l'argent dans la facture et expédie le tout dans une boîte close, par tube pneumatique, à la caisse centrale. Il existe des douzaines de ces tubes dans l'établissement, lesquels viennent aboutir au bureau central, situé dans le sous-sol. Des groupes de sept ou huit tubes sont desservis par une employée qui reçoit les boîtes, les ouvre, retire l'argent des factures, en détache un talon de contrôle, inscrit la vente sur un registre, remet la monnaie dans la facture, enferme le tout dans la boîte et renvoie celle-ci par le tube aboutissant au rayon. Pendant ce temps, le vendeur s'occupe d'une autre acheteuse et l'employée du pupitre enveloppe la soierie. L'opération totale s'effectue dans un temps minimum.

Pendant que j'inspectais le bureau central, il arrivait fréquemment des factures sans argent. Celles-ci provenaient de ventes faites à des acheteuses ayant déclaré avoir un compte ouvert chez Wanamaker. Dans ce cas la receveuse jette la facture derrière elle, sur une grande table où sont disposés les livres des comptes courants. Un employé attentif circule incessamment le long de cette table, saisit la facture, y jette un coup d'œil et prononce à mi-voix : *All right*, puis rend la facture. Il connaît par cœur les noms de toutes les titulaires de comptes courants. En cas d'hésitation, il a les registres à sa portée.

Mais, bien que je lui aie vu contrôler plusieurs centaines de factures, pendant mon court séjour dans le bureau, pas une seule fois il n'eut recours à ses registres de références. Aussitôt vérifiée, la facture est retournée par pneumatique à son rayon d'origine.

fig. 63

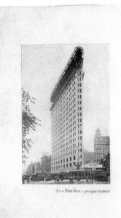

Le « Flat Iron » presque terminé

This simultaneous image of the skyscraper naked, half dressed and clothed is enormously popular, as the pages of countless photo albums show. Of course the garb of these New York skyscrapers is not of glass but of classical compositions in stone that, in the last analysis, hide their magnificent metallic structures. But the fact that the process is exposed in this way is already, from the popular point of view, sufficient as a spectacle, not unlike that offered by X-rays, whose power consists in revealing what was hidden, in a wonderfully banal—and therefore, as we know, terrible—seeing through.

This was to be another important theme, as I said above, for the pioneering New York photographers, and on it, too, they impose upon their pictorialist interpretation. One example will suffice. *Old and New New York* [fig. 65] is the eloquent title of a famous 1910 photograph by Stieglitz, published the following year in *Camera Work*, which could rightly be described as inaugural: the ground-level camera shows us a row of houses with classical façades and picturesque roofs, while in the background, swathed in the familiar mist, there rises a metal structure under construction, every bit as orthogonal and transparent as Mies's projects. In *L'Esprit Nouveau* [fig. 64] in 1923, and subsequently in *Urbanism* [fig. 66], Le Corbusier did not dissimulate that origin, noting laconically under a photograph of a skyscraper in construction very similar to Stieglitz's (albeit more machinist: there is a tram in the foreground): 'A building... just put glass around it.'[18] A little later, in 1924, the editors of the second issue of the new magazine *ABC* did the same thing with the same image [fig. 67], taken no doubt from one of the popular publications we have mentioned, comparing it with an Emil Roth photograph of a dandelion (*Taraxacum officinale*), a flower that is like 'a tower that withstands the wind, constructed with total economy' in which 'the *fantasy* [imaginative genius] consists in responding exactly to the function', identical to the 'diaphanous skeleton' of the skyscraper,[19] to give two extreme examples, among many others. But in his text Mies talks about other things that have little to do with the diaphanous transparency, technical rationalism and functionality that Le Corbusier and *ABC*, each in their own way, admired in such naked structures. He also says, and not just in passing, that although the form of the skin, with curves and edges, may seem arbitrary, it is actually the result of much study of the possibility of its reflections. Arbitrary it certainly seemed, of course, to Mart Stam, who in number 3-4 of *ABC*,[20] 'replying' to both Le Corbusier and Mies, modified the structure of Mies's skyscraper, reducing it to a single central pillar of concrete, and also corrected its form, removing all of the anecdotal details and transforming it into a pure cylinder, 'existential minimum'.

fig. 64, following pages fig. 65, 66

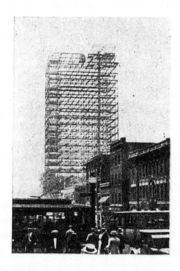

Les Temps modernes (*l'Acier*)

Les Temps modernes (le *ciment armé*)

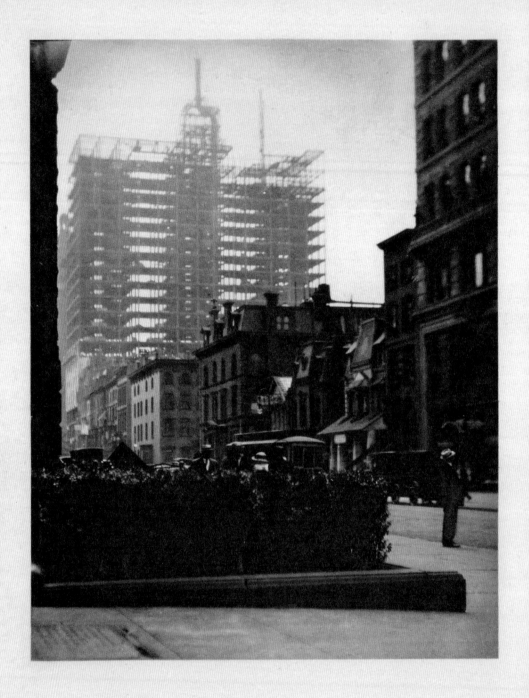

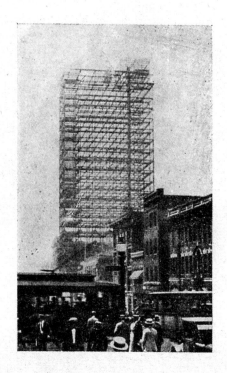

Un building ... On met du verre autour.

GESTALTEN=FORM.

Ein Stengel kreisrund, hohl — der widerstandsfähigste Quer=
schnitt — so hoch dem Wind entgegen als die Kräfte reichen;
darauf eine Kugel — die eigenste Gestalt vieler gleichwertigen,
dicht auf einem Kissen sitzenden Samen. Der Wind streicht
darüber, die Form zerstiebt, eine neue löst sich — ein Korn an
federleichtem Schirm. Und wieder nach seiner Zeit zerfällt auch
dieses Gebilde; Blätter sprossen daraus, Blütenstiele treiben
und von neuem entfaltet sich die Samenkugel. Derart ist die
„Phantasie", der gestaltende Wille einer Pflanze — eines jeden
Geschöpfes. Form ist Ausdruck erfüllter Aufgabe, nur Stufe:
pietätlos, grausam preisgegeben dem Zerfall, der Umwandlung
nach erfüllter Aufgabe. Stetig, uns unfassbar ist der gestal=
tende Wille; die Form nur wiederkehrend — gleich im Dienste
derselben Aufgabe, gebunden an denselben Stoff.
Form ist Ausdruck erfüllter Aufgabe, gebunden, vergänglich —
und dennoch kann uns nichts hindern, uns zu freuen an ihren
bedingten Vollkommenheit.

So gestaltet der Mensch, im Dienste einer Pflicht stehend: Er=
füllung ist Ziel, nicht Form; Form nur der Masstab, Er=
füllung zu messen.
Form hat nichts Ewiges an sich, ist gebunden an Zeit und
Möglichkeit — und um so mehr wird es uns freuen in ihrer
bedingten Vollkommenheit.
DIES MÖGEN AUCH DIE ARCHITEKTEN BEDEN=
KEN.

Erfahrungsgemäss ist für diese Akten sogar das alte Folio, vor allem
in der Breite, zu knapp. Das VSM Format 210 × 297 erzielt, im Be=
streben den Ausgleich zwischen Oktav und Folio zu schaffen, keine geeig=
nete Grösse für Zeitschriften, Bücher etc. Ausserdem ist das genaue Ver=
hältnis 1 : 1,41 unwichtig, die Aufrundung auf 1 : 1,4 genügt praktisch
allen Ansprüchen.

Wir schlagen daher vor, die vom VSM nur zur Aushilfe verwendete
Reihe B unter Aufrundung des Verhältnisses 1 : $\sqrt{2}$ als „metrische Reihe"
einzusetzen, wie wir sie für unsern eigenen Gebrauch schon längere Zeit
verwendet und erprobt haben:

Metrische Reihe	VSM=B=Reihe	
1000 × 1400 mm	1000 × 1410 mm	
700 × 1000 „	707 × 1000 „	Zeichnungen, Plakate.
500 × 700 „	500 × 707 „	Zeichnungen.
350 × 500 „	353 × 500 „	Zeichn'gen, Zeitungen, Tafelwerke.
250 × 350 „	250 × 353 „	Zeitschriften und Bücher (Gross= format), Normenblätter, Kostenan= schläge, Aufstellungen, Akten.
175 × 250 „	176 × 250 „	Zeitschriften und Bücher (Klein= format), Briefe, Mitteilungen, Bro= schüren, Kataloge.
125 × 175 „	125 × 176 „	Bücher (Taschenformat), Notiz= blöcke, Postkarten.

DIE NEUE WELT.

Im November des vergangenen Jahres sprach der Holländer R. N. Roland Holst
in der Pariser Sorbonne über die Entwicklung und Verwirklichung des architek=
tonischen Gedankens in Holland. Wir übersetzen aus der bei C. A. Mees in
Sandpoort (Holland) erschienenen gedruckten Ausgabe die folgenden Abschnitte:

In der Kunst spielt das, was man die „Entdeckung" nennen könnte, eine
nicht unbedeutende Rolle.

Ein Bild mag dies deutlicher ausdrücken: Die am Horizont auftauchenden
Küsten Amerikas hatten für Kolombus und seine Mannschaften mehr und
tieferes zu bedeuten, als dieselben Küsten heute für die Tausende be=
deuten, die täglich in den Hafen von New=York einfahren.

Die holländischen Maler des XVII. Jahrhunderts entdeckten eine neue
Welt, unsere Zeitgenossen bereisen sie. Gilt dasselbe nicht für alle Län=
der der westlichen Kultur?

Je länger ein Land bereist wird, desto bequemer wird das Reisen da:in,
je mehr ein Land bereist wird, desto mehr Menschen kommen, um es zu
bereisen. Liegt darin vielleicht die Erklärung dafür, dass es gegenwärtig
in allen Ländern so wenig Maler gibt, und auch dafür, dass jeder dieser
Maler im Stande ist, soviel zu leisten?

Die besten Maler von heute stehen, davon bin ich im innersten überzeugt,
den besten Malern von früher keineswegs nach; aber das Schicksal wollte
es, dass sie in einem Weltteil auf Entdeckungsreisen gehen, der schon
vor langer Zeit entdeckt wurde.

Sie sind den früheren Künstlern ebenbürtig an Talent, Beseelung und
Schöpferkraft, aber ihre Zeit kommt ihnen nicht zu Hilfe. Sie werden
nicht getragen durch mächtige Ströme, die durch dieselben Kräfte aufgestaut
werden, wie sie in der ganzen Lebensgemeinschaft selbst am Werk sind
und so den Einzelnen über seine persönliche Begabung hinauszuheben
vermögen. Sie unterliegen der ewig tragischen und zugleich trostreichen
Abhängigkeit, die das Leben fordert.

So sind die Künstler wie die Saat; die Saat ist stets gleich triebkräftig,
aber die Zeit bestimmt die Reife. Die Früchte der Pflanzen, die in der
günstigen Jahreszeit zum Wachstum kamen, als die Tage lang waren und
die Sonne ihre volle Kraft besass, sie werden reifen; aber die Früchte
der Pflanzen, die zu spät im Jahre aufwuchsen, werden nie zu vollkom=
mener Reife gelangen.

Der architektonischen Idee fällt heute die Aufgabe zu, eine neue Welt
zu entdecken — sie hat sie eigentlich bereits entdeckt.

Dieses neue Land ist sicherlich kein Ausflugsgebiet für ästhetische Touristen;
denn es fehlt hier buchstäblich noch an allem, was der ästhetisch fein em=
pfindende zum Leben braucht. Das Dasein ist in diesem neuen Weltteil
des Geistes noch hart und auf die hinderlichste Weise an die gewöhnlichen
materiellen Forderungen gebunden; alle Zustände sind hier noch unsicher,
die Enttäuschungen, selbst von seiten der Kräfte, die mithelfen sollen,
sind schwer und drückend; was erreicht worden ist, steht sich noch in
keinem Verhältnis zur Anspannung, die daran gewendet wurde.

Und doch ist es eine neue Welt, auf deren Boden die architektonische
Idee den Fuss gesetzt hat:

Die alte Welt war der Ort des unendlich nuancierten subjektiven Gefühls.
Die neue Welt ist der Ort des synthetisch gebauten Lebensbegriffes.

Die architektonische Idee stützt sich — muss sich stützen — auf ein starkes
Gesellschaftsbewusstsein, sie ist in ihren Absichten altruistisch und nicht
egozentrisch. Dem heute überherrschenden subjektiven Gefühl dagegen
entspricht die geistige Vereinsamung, die Abkehr von der Gesellschaft,

(Bildbeschriftungen seitlich:) TARAXACUM OFFICINALE L. XIX

BETONIERANLAGE KRAFTWERK WÄGGITAL

das Streben nach einer ausgesprochenen persönlichen Lebensauffassung. Für das subjektive Gefühl besitzt die schönste Architektur vor allem ästhetischen Wert — die grosse gesellschaftliche, moralische und synthetische Bedeutung der Architektur kann durch den Subjektivisten wohl verstandesmässig begriffen, aber nie in ihrer tiefsten Bedeutung erfasst werden, — so gut wie das subjektive Gefühl keine Macht besitzt, die architektonische Idee in ihrem tiefsten Wesen zu beeinflussen.

Denn was wir heute erleben, nicht nur in Holland, sondern in ganz Europa, ist keine ästhetische Laune, sondern eine psychologische Umkehr, ist keine Erscheinung, sondern eine Kulturwandlung, die noch lange nicht zur nationalen Differenzierung vorgedrungen ist — und wo diese sich in den Vordergrund drängt, da ist sie von höherer Warte gesehen meiner Meinung nach wertlos.

Was wir heute erleben, ist das Durchbrechen eines der Renaissance entgegengerichteten Geistes, das erste Lebenszeichen einer Erneuerung. Das Italien der Renaissance brachte uns den Sieg des Persönlichkeitsgefühls, die Befreiung des Individuums. Was wir heute sehen, ist dasselbe Ringen, das sich nach fünf Jahrhunderten wiederholt, jedoch in umgekehrter Richtung. Heute sehen wir, wie die architektonische Idee, anders als im Mittelalter, jedoch nicht weniger absolut, nach der Verwirklichung drängt.

Die Umwälzung hatte in Italien — im Grossen gesehen — vom 13. bis zum 15. Jahrhundert gedauert. Wie lange die neue Umwälzung dauern soll, wer kann das zum Voraus sagen? In keinem der europäischen Kulturländer ist der Streit zwischen den beiden entgegengesetzten Ueberzeugungen älter als dreissig Jahre. Und was bedeuten dreissig Jahre in der Entwicklung einer Kultur?

DIE REKLAME.

Die Reklame ist in der heutigen Gemeinschaftsordnung eine Notwendigkeit geworden, eine Folge des Konkurrenztriebes. Die Reklame wirkt auf das Publikum durch die Mitteilung, — stärker noch durch Propaganda, — noch stärker selbst durch Suggestion.

Für eine zielbewusste Reklame ist ausser einem klaren Einblick in das gegebene Material, vor allem psychologisches Erkennen notwendig.

1. Das Plakat.

a) Die Ware wird genannt.

Die Mitteilung geschieht durch den Text. Der dynamische Ausdruck des gegebenen Wortmaterials muss eindeutig ausgebaut werden. Alles Nebensächliche ist weg zu lassen. Kenntnis des Publikums gibt die Gewähr, dass kurze Aussprüche und Namen im Gedächtnis haften bleiben, während ein Ueberfluss an Worten nur schadet.

Wie man den Text zu setzen, über das Plakatfeld zu verteilen hat, wird man wissen, sobald man sich Rechenschaft gegeben hat über das Lesen und über das Wie des Lesens selbst; darüber, ob überhaupt gelesen wird, oder ob Worte, Namen oder Marke bloss erkannt werden.

Die Farbe und die Form dienen dazu, den Text lesbar zu machen, sie haben das in richtiger Weise zu tun, d. h.

jedes Preisgeben der Lesbarkeit um der Farbe willen ist ein Fehler,

jedes Preisgeben der Lesbarkeit um der Form willen ist ein Fehler.

Jede reizvolle Linie, jede Zierlichkeit und Farbennuancierung sind dem Zweck der Reklame vollkommen fremd und können nur schaden.

b) Die Ware wird gezeigt.

Es ist zu beachten, dass der moderne Mensch (besonders der Grosstadt) von Aufschriften und Plakaten überflutet ist, darum ist es höchst zweckmässig, anstatt die Ware zu nennen, sie zu zeigen. Neben dem Plakat mit mitteilendem Text entsteht eine ganz andere Form, deren Mittel die Darstellung ist. Die photographische Darstellung des reklamierenden Gegenstandes selbst, oder seiner Wirkung, oder beides zusammen, füllen allein die ganze Plakatfläche aus. Der Gegenstand trägt auf sich die Firma oder die Fabrikmarke, durch die Anschaulichkeit allein prägt er sich stumm in das Gedächtnis des Vorbeieilenden. Für diesen Zweck ist eine photomechanische Reproduktion, mit einem markanten Signet versehen, jeder mehr oder weniger geschickt gezeichneten oder gemalten Abbildung vorzuziehen. Auch hier gert reklametechnisch und künstlerisch

DAS EXAKTE ÜBER DAS VERSCHWOMMENE,
DIE WIRKLICHKEIT ÜBER DIE NACHAHMUNG.

Auf diesen zwei Wegen:

1. Der äussersten Organisation des lesbaren Textes, der Farbe und der Form zu funktioneller Kraft (Abb. 4),
2. der photomechanischen Reproduktion des Gegenstandes (Abb. 5), wird das moderne Plakat sich entwickeln.

Für die moderne Reklame und für den modernen Gestalter ist das individuelle Element, (des Künstlers „eigener Strich") total belanglos. Die Schnörkel der Rokokokalligraphen sind sehr zierlich, aber . . .

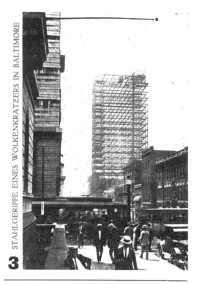

STAHLGERIPPE EINES WOLKENKRATZERS IN BALTIMORE

3

EINE KOPFRECHNUNG.

1,500,000 FRANKEN sollen auf Wunsch der Stadt Zürich für den Bau des neuen Bahnhofs in der Enge nach dem Monumentalprojekt erster Architekten ausgegeben werden.

800,000 FRANKEN hätte derselbe Bahnhof nach dem „nur" praktischen Projekt der Schweizerischen Bundesbahnen gekostet.

700,000 FRANKEN rechnen wir aus als Differenz, als reinen Idealismus — oder andersherum der neue Bahnhof muss notwendigerweise zu 46,5 % aus reiner und angewandter Schönheit bestehen.

Wir sind ein wenig beschämt. Denn wir hatten geglaubt, unsere Arbeit — seien wir nun Architekten, Ingenieure oder Stadträte — habe den Forderungen des Verkehrs zu dienen, und hatten bereits ausgerechnet, wie viel Quadratmeter der schönsten Automobilstrasse nach dem neusten Verfahren wir für Fr. 700,000.— hätten herstellen können. Dafür sind wir eben auch Materialisten.

PLAKAT-ENTWURF VON M. STAM

4

Wissen Sie, was die Kunstmoral über die Reklame sagt:

Plakatkunst ist Prostitution der Malerei, so wie Journalismus Prostitution der Literatur und Kino Prostitution des Theaters — und Kukirol Prostitution der Hühneraugen.

In contrast, in his text Mies placed particular emphasis on the importance of the reflections of the glass skin, and the low-angle photograph of the model also published in *Frühlicht* [fig. 68] gives the impression of having been taken for that very purpose: in order to check the curves and edges and study the shine of the skin, at once transparent and opaque. It is, after all, in the act of holding this model up against the sunlight that Mies was caricatured at the time by Sergius Ruegenberg [fig. 69].

However, the way in which Mies asserts the crystalline perfection of his work in this montage published in *Frühlicht* might seem cartoonish for reasons very different from those adduced by Mart Stam and his colleagues at *ABC*. For a start, the background is not the clear sky against which the transparency of the skyscraper is silhouetted but a smooth, homogeneously darkened surface that gives the skyscraper a strangely nocturnal, even spectral air—and not exactly in the way we have hitherto ascribed to these 'sensations'. In effect, the skyscraper is projected—as we have become used to seeing—against the black background, rendering it transparent but unexpectedly presenting it as illuminated from without, not from within. This is what we have seen in the photomontages of the building on Friedrichstraße, which was, like the American skyscrapers under construction, pierced by light: this, of course, had always been done by the Expressionist architects [fig. 70, 71, 73] who made their glass buildings radiant beacons, themselves producing light, and has been done for some time now by advertising, which delights in night shots of buildings to represent the life of the modern city, façades blazing with neon and floodlit billboards and windows brilliantly illuminated, as if they were transformed by night into negative images of their daytime selves [fig. 72, 74].

In 1931, for example, to cite a particularly exotic case as an example of the limitless circulation of these images, between somewhat equivocal photographs—fashion, avant-garde shots and 'modern life' in general—a double-page spread in a Japanese publication popular with devotees of ero-guro-nansensu (the erotic, the grotesque and nonsense) in the twenties and thirties showed the *Frühlicht* montage of Mies's skyscraper alongside a characteristic night view of the De Volharding cooperative building in The Hague completed by J.W.E. Buijs and J. B. Lürsen in 1928, lit from within [fig. 75].[21]

FRÜHLICHT

HERAUSGEBER BRUNO TAUT

KARL PETERS VERLAG IN MAGDEBURG

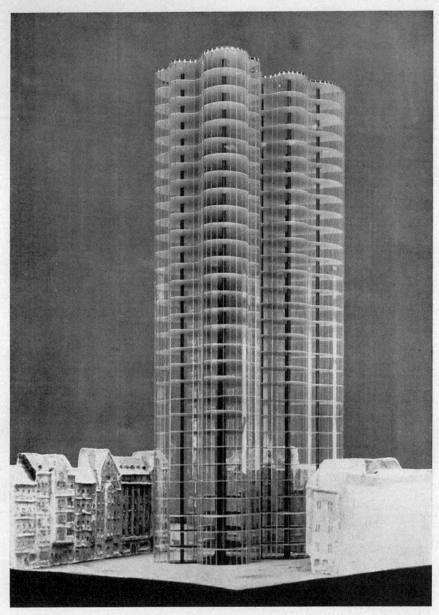

Ludwig Mies van der Rohe: Hochhaus

122

Grundriß zum Hochhause Seite 122

Bruno Taut: Ausstellungsbau in Glas mit Tageslichtkino
(Entwurf)

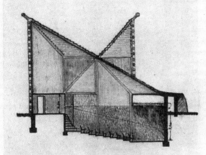

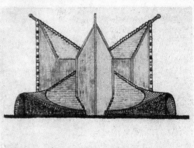

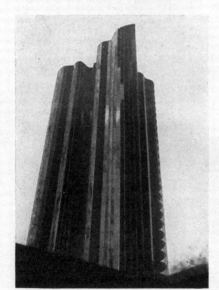

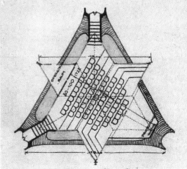

Hochhaus Seite 122 von unten gesehen

Nur im Bau befindliche Wolkenkratzer zeigen die kühnen konstruktiven Gedanken, und überwältigend ist dann der Eindruck der hochragenden Stahlskelette. Mit der Ausmauerung der Fronten wird dieser Eindruck vollständig zerstört, der konstruktive Gedanke, die notwendige Grundlage für die künstlerische Gestaltung vernichtet und meist von einem sinnlosen und trivialen Formenwust überwuchert. Im besten Fall imponiert jetzt nur die tatsächliche Größe, und doch hätten diese Bauten mehr sein können als eine Manifestation unseres technischen Könnens. Allerdings müßte man auf den Versuch verzichten, mit den überlieferten Formen eine neue Aufgabe zu lösen, vielmehr ist aus dem Wesen der neuen Aufgabe heraus die Gestaltung ihrer Form zu versuchen.

Das neuartige, konstruktive Prinzip dieser Bauten tritt dann klar hervor, wenn man für die nun nicht mehr tragenden Außenwände Glas verwendet. Die Verwendung von Glas zwingt allerdings zu neuen Wegen,

Bei meinem Entwurf für das

Mies van der Rohe:
Hochhausprojekt für Bahnhof Friedrichstraße in Berlin

Hochhaus am Friedrichsbahnhof in Berlin, für das ein dreieckiger Bauplatz zur Verfügung stand, schien mir für diesen Bau eine dem Dreieck angepaßte prismatische Form die richtige Lösung zu sein, und ich winkelte die einzelnen Frontflächen leicht gegeneinander, um der Gefahr der toten Wirkung auszuweichen, die sich oft bei der Verwendung von Glas in großen Flächen ergibt. Meine Versuche an einem Glasmodell wiesen mir den Weg, und ich erkannte bald, daß es bei der Verwendung von Glas nicht auf eine Wirkung von Licht und Schatten, sondern auf ein reiches Spiel von Lichtreflexen ankam. Das habe ich bei dem anderen hier veröffentlichten Entwurf angestrebt.(S.122-23.) Bei oberflächlicher Betrachtung erscheint die Umrißlinie des Grundrisses willkürlich, und doch ist sie das Ergebnis vieler Versuche an dem Glasmodell. Für die Kurven waren bestimmend die Belichtung des Gebäudeinneren, die Wirkung der Baumasse im Straßenbild und zuletzt das Spiel der erstrebten Lichtreflexe. Umrißlinien des Grundrisses, bei dem die Kurven auf Licht und Schatten berechnet waren, erwiesen sich am Modell bei der Verwendung von Glas als gänzlich ungeeignet. Die einzigen im Grundriß feststehenden Punkte sind die Treppen- und Aufzugstürme.

Alle anderen Unterteilungen des Grundrisses sollen den jeweiligen Bedürfnissen angepaßt und in Glas ausgeführt werden.

Mies van der Rohe

Reklamebau des schwedischen Balletts
Berlin, am Potsdamer Platz

Laden Krielke in Schöneberg
von Arthur Götz

fig. 69

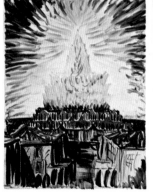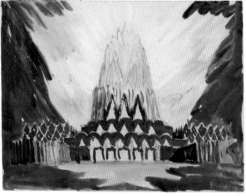

fig. 70, 71

NEW YORK
BROADWAY BEI NACHT

Unheimlich. Die Konturen der Häuser sind ausgewischt. Aber im Bewußtsein steigen sie noch, laufen einander nach, überrennen sich.

Das ist die Folie für die Flammenschriften, das Raketenfeuer der beweglichen Lichtreklame, auf- und untertauchend, verschwindend und ausbrechend über den Tausenden von Autos und dem Lustwirbel der Menschen.

Noch ungeordnet, weil übersteigert, aber doch schon voll von phantastischer Schönheit, die einmal vollendet sein wird.

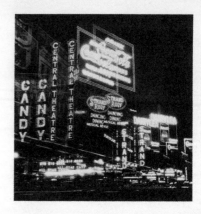

fig. 72

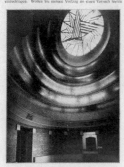

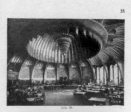

fig. 73

fig. 74

STUTTGART
Lichthaus Luz. Architekt Dr. Richard Döcker

HAMBURG
Großkino Emelka-Palast. Architekt Karl Schneider

KOPP & JOSEPH

BERLIN. Parfümerieladen am Kurfürstendamm. Architekt Artur Korn

Rechts:
BERLIN. Umbau in der Tauentzienstraße.
Architekt: Brüder Luckhardt u. Alfons Anker

wendigen Straßenraum zu gewinnen und dabei doch den Gebäuden die nötige Licht- und Luftzufuhr zu sichern.

In Ergänzung eines bereits 1924 aufgestellten Vorschlags zur Planung einer Hochhausstadt demonstriert das im Märzheft des „Kunstblatt" abgebildete Schema einer Citybebauung mit Hochhäusern eine Bebauungsmöglichkeit, die alle diese Vorteile erreicht, ohne dabei die Geländeausnutzung und Bebauungsmöglichkeit zu steigern; lediglich durch andere Verteilung der Baumasse auf dem Gelände, durch ihre Konzentrierung zu Hochhäusern. Dadurch ergeben sich die notwendigen großen Abstände, die im Minimum der Gebäudehöhe entsprechen müssen. Diese gestatten die Anordnung eines Straßenfystems in mehreren Etagen und damit eine vollkommene Trennung des Fußgänger- vom Wagenverkehr, und ermöglichen außerdem Parkplätze für Autos auf allen Straßen anzuordnen. In den Höfen, die die gleichen Breitenabmessungen wie die Straße haben, lassen sich außerdem bei vollkommen freier Grundrißentfaltung je nach Bedarf Ausstellungs-, Verkaufs- und Lagerhallen einbauen.

Im Gegensatz zu allen Teilfölungen hat ein solcher Vorschlag einen Umbau der gesamten Innenstadt zur Folge, ein Unternehmen, dessen Kosten garnicht abzusehen find. Trotzdem follten alle Teilfölungen im Hinblick auf den umfassendsten Plan vorgenommen werden, denn was die heutige Stadt unmöglich macht, ist ihr Grundriß, der durch alle Teilverbesserungen nicht verändert wird.

fig. 75

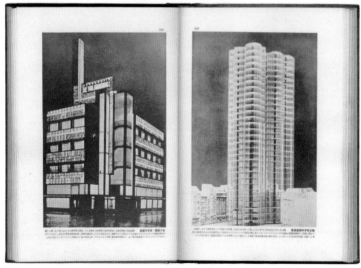

No doubt the Japanese editors were attempting to draw attention to the equivalence or at least the continuity of the two images, as, indeed, they did in the rest of the publication, which ranged from paintings by De Chirico and Joan Miró and photomontages by Hanna Höch and Umbo, by way of African masks and the Tiller Girls, to more or less artistic or psychaliptic pictures of naked girls. However, the result of this juxtaposition is quite other. In the Mies montage there is nothing of the *plénitude*—electric because modern and modern because electric—that we see in the photograph of the building in The Hague, and the contradiction produced between the darkness of the sky and the entirely exterior illumination of the skyscraper, required by the reflections, serves only to enhance the impression of a skeleton and to evidence all the more, so to speak, its *de*-carnation, while at the same time, surrounded by its brightness, instead of opening out, it seems to wrap itself up, to close in on itself.

However, what is even more unusual in the *Frühlicht* montage is the contrast between the adamantine perfection of the skyscraper and the houses it rises above. The old city has been represented by picturesque houses with sloping roofs and softened façades, which have very little to do with the image of a metropolis and a great deal with that somewhat sinister idealization of the mediaeval city that had been characteristic of Expressionist architects and filmmakers. One might think here, indeed, as has happened on more than one occasion, of the houses that Poelzig designed for Paul Wegener and Carl Boese's *The Golem* in 1920 [fig. 78], and also, more probably, of the city that, in the monumental views of Bruno Taut's revelations, insistently surrounds its own crown.

We might even think Mies is commenting, ironically and more or less consciously, on the illustrations of Taut's *The City Crown* [fig. 80], starting with the first, which is the frontispiece—Van Eyck's drawing *Saint Barbara* in which a magnificent Gothic tower under construction rises over the little wooden hut at its feet in which, no doubt, its architect lives—and continuing on through all those images in which all kinds of towers, steeples and spires soar potently above the mass of a town that almost always consists of little houses with sloping roofs.[22]

The Mies building, however, is no 'glass cathedral' but, as we know, a radiographic apparition of technology and production in all their cold distance from the human: Medusa on one side, Sphinx on the other, frozen reflection, antimystical night in any case, or, ultimately, not a 'cathedral' but a monolith of glass [fig. 76, 77].

As we have seen, Mies represents his skyscrapers as transparent at times, but at others opaque. Above all in their elevations these buildings take on the appearance of a black prism, vertically furrowed by radiant flutings. If such drawings impress us—*freeze* us—it is precisely because in them absolute opacity and absolute transparency are fused to become a single thing. These skyscrapers are in fact, as I say, monoliths: the black stone, polished and gleaming, which is worshiped in fear. Or they are the Sphinx, deaf and dumb, whom we question in vain. The monolith and the Sphinx are silent because they are empty: in their menacing and perfect vacuity lies their mysterious power.

But let us return to the *Frühlicht* montage [fig. 68]. What interests Mies here is the contrast between the most crystalline possible, between the hystericizing of the crystalline—in that the crystalline is the sign of modern production, of 'products of production'—and the mass of the houses, perhaps made of gingerbread, like the house the children find in the fairy-tale forest, or perhaps of *papier maché*, plaster or even clay, but in any case modelled in an all but formless, massive, viscous paste: it is amazing to bring our eyes closer and see the burrs around the openings in these houses or the softening of their frames, not much different from that suffered by the stone in Gaudí's work, another gingerbread architecture, and one that had, incidentally, attracted the early interest of the *Frühlicht* editors [fig. 79]. Manifestly, Mies's building does not rise up, as was to be expected, in the modern city, as the ultimate conclusion of its modernity, but against the mass of a different city, a different time. In short, these soft little houses seem to mock life 'with no traces', to refer once again to Benjamin's famous observation, but bearing in mind how far the traces here, by their modelling by the hands of their enemies, coincide with the uncanny.

So, then, this model was published in *Frühlicht*—in its final issue, indeed—as a manifesto and as an X-ray.

But let's shift to another sphere and straightaway take a look at a Barcelona magazine of the nineteen twenties, a truly popular publication by the name of *Algo* [fig. 82], with the sub-masthead—by way of explanation—'encyclopaedic illustrated and humorous weekly'. We shall start with the issue dated 12 April 1930. The front cover depicts one of those 'spectacular' moments of modern life—and I use the word in the literal sense that advertising was already starting to give it in

124

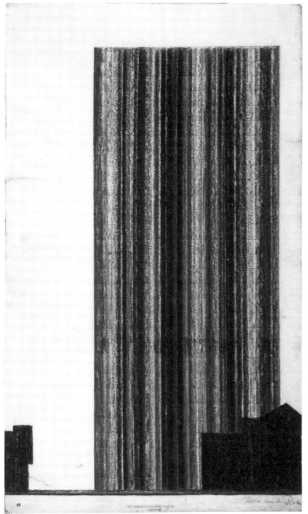

fig. 76, 77

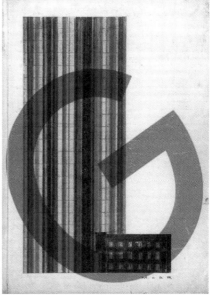

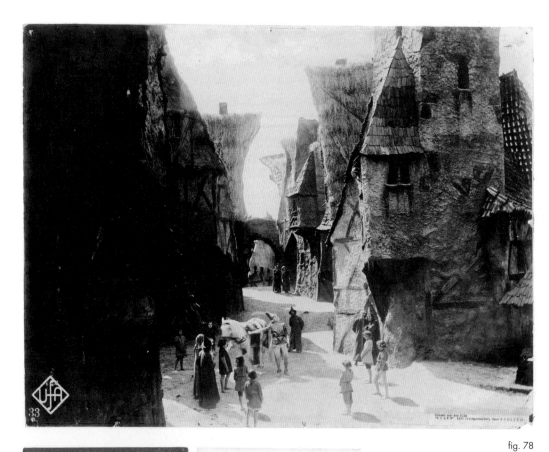

fig. 78

fig. 79

20. Buarcos

21. Tzaffin

32

13. Köln

14. London

27

fig. 80

that period as referring to the masses and their condition as spectacle in and of themselves, to the condition at once specular and spectacular that modern life assigns to the crowd. In this case, a gigantic, obviously disproportionate airship is moored to the top of the Empire State Building in New York, which was then under construction. All of the popular themes of modernity appear here in condensed form: the metropolis, the great inventions, the modern means of transport, especially by air, and, of course, the great skyscraper—and, above all, the size, the disproportion, the gigantism to which the covers of magazines such as, to look no further afield, *Scientific American* [fig. 81] had accustomed the public. Those are the themes of America's seduction of the masses, based on the presentation of a future as present, but as the present from another place, not yet reached, mythical: an America at once mythicized and mystified.

Like many other popular magazines of the time, in its brief eight pages *Algo* touches on all of these things: exotic destinations, scientific curiosities, popular science, science fiction, surprising technological advances, medical breakthroughs, interplanetary or underwater travel, expeditions to unknown places, sporting achievements, film stars, robots and all kinds of more or less domestic gadgets, from the dishwasher to the television, not to mention bioevolution, criminal anthropology, X-rays, and so on. Typical sections are entitled 'Small Inventions', 'Did You Know?', 'Picturesque Scenes around the World', 'Wonders of Nature' and 'Believe It or Not'. What we have here, then, is the popularization of the old bourgeois utopia of infinite progress of science and technology: now, the optimistic announcement of a bright future has become a great spectacle, constantly in the news. Such populism gave rise to covers like this, and fed on them in turn. In the nineteen twenties the image of New York was absolutely indispensable, as the city of the future in the present *par excellence* [fig. 83]. In any case, we should not be surprised at the cover of *Algo* for 16 November 1929 [fig. 86], absolutely typical of depictions of the city of the twentieth century as imagined in the nineteenth, in the style of Albert Robida [fig. 84, 85], for example, in futuristic novels such as *The Twentieth Century* (just so), or of the famous turn-of-the-century vistas of the city of the future of Moses King [fig. 88] or Harvey Wiley Corbett [fig. 90], with their characteristic strata of air and underground traffic, with motor cars, aircraft and airships of all kinds, their prospects of skyscrapers connected by bridges, etc, etc. In this popular vision, the naive anachronism does not matter; rather, it is a necessary condition: only what is recognized is accepted—the new as always the same—in the populist advertising strategy.

fig. 81

SCIENTIFIC AMERICAN

[Entered at the Post Office of New York, N. Y., as Second Class Matter. Copyright, 1909, by Munn & Co.]

Vol. C.—No. 26.]
Established 1845.]

NEW YORK, JUNE 26, 1909.

[10 CENTS A COPY
[$3.00 A YEAR.

The "Zeppelin II" is nearly as long as the battleship "Louisiana."

If the Metropolitan Tower were to fall, how far would it extend ?

THE METROPOLITAN TOWER AND THE "ZEPPELIN II."—[See page 478.]

ALGO

AÑO II-NÚM. 55 SEMANARIO ILUSTRADO ENCICLOPÉDICO Y DE BUEN HUMOR 12 ABRIL DE 1930

DIPUTACIÓN, 211, BARCELONA · VALVERDE, 21 dup., MADRID

EN ESTE NÚMERO

Pequeños inventos.
¿Sabe usted?...
Curiosidades de la vida animal.
Interesantísimo Panorama Pintoresco Universal.

MÁSTIL-RASCACIELOS

Este mástil gigantesco de 83 pisos lo está levantando, en la Quinta Avenida de Nueva York, la sociedad «Empire State Building» para amarrar los dirigibles de sus líneas.

30 céntimos

5 páginas de variedades
48 páginas de folletines

fig. 82

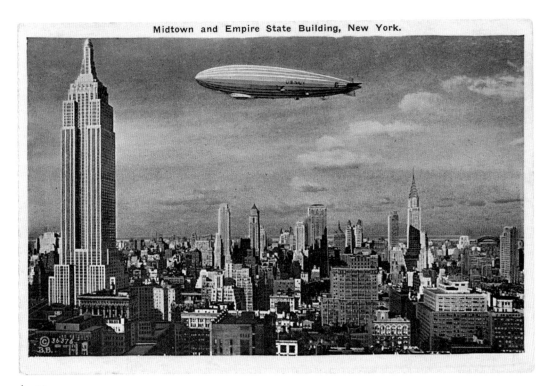

Midtown and Empire State Building, New York.

fig. 83

fig. 84, 85

ALGO

SEMANARIO ILUSTRADO ENCICLOPÉDICO Y DE BUEN HUMOR

AÑO I - NÚM. 34

REDACCIÓN Y ADMINISTRACIÓN: DIPUTACIÓN, 211, BARCELONA

16 NOVIEMBRE DE 1929

DENTRO DE VEINTE AÑOS

Un aspecto de la circulación en las ciudades modernas.

CON ESTE NÚMERO DEBE RECIBIR EL LECTOR LAS ENTREGAS GRATUITAS, QUE REPARTIMOS APARTE, DE

LA TIERRA Y SUS POBLADORES **EL HUSAR AZUL Y DOS HOMBRES MALOS** **TEATRO SELECTO**

(Geografía Universal) (Novela) (Obras teatrales)

fig. 87, 88

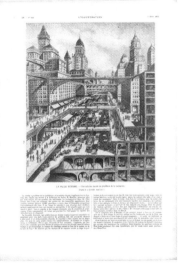

fig. 89, 90

fig. 86

For example, on the subject of anachronism, an article by Laura Brunet, also from 1929, was illustrated with an 'adaptation' of Moses King's perspective as a 'vision of the future Barcelona' simply by adding a few buildings from Via Laietana—Barcelona's most modern street at that time—and, on the right, the Gothic towers and spires of the cathedral [fig. 87].[23] In a not too different way, though we are dealing now not with plagiarism but with a subtler iconic persistence of the popular, the *Algo* illustration [fig. 86] is vaguely reminiscent of, for example, the avenues of skyscrapers drawn by Jacques Lambert in 1922 [fig. 89], which, though they come from 'high' culture (the project was by Perret) and appeared in avant-garde media such as *L'Esprit Nouveau* or *Urbanism*, had previously been published in popular magazines such as *L'Illustration*. We could search out the source from which the contributors to *Algo* copied or adapted their city of the future—no doubt some other popular periodical like their own—but that is not the most important thing. What is of interest to us here is the fact that rational buildings, arranged according to their own structural grids and logically closer to those of Perret and Lambert than to those of Moses King, are dropped into a setting that continues nevertheless to be that of a persistent imaginary from the nineteenth century. In these images, in fact, the city is first and foremost traffic: what we see in them, in short, is the *productive* popularization of the future.

But let's go on browsing. Again, we should not be surprised at the cover of *Algo* for 22 March 1930 [fig. 92], which shows spherical houses that the magazine says 'have begun to be built' in Germany. In this case we do know the source: the Kugelhaus [fig. 91], an experimental building designed for the Messe trade fair grounds in Dresden by Peter Birkenholz in 1928, which had proved very popular. But this one-off project becomes, in *Algo* once again, a whole city. Spherical houses, as we read in the inside pages, 'while very spacious above, are so narrow at their base that they take up hardly any room... in order to leave more space free for traffic'. That which is amazing in its eccentricity is an essential part of the popularization of the future, but what counts for as much or more here is that these houses 'have begun to be built in Germany' and that 'some experts' consider them to be 'Europe's most original and modern' buildings. Germany, then, is the other great symbol of modernity, the appreciation of which is identified largely with its architecture. In the twenties, in effect, 'Germany' and 'modern architecture' were synonymous, as can be seen from a look at almost any European avant-garde magazine of the time. However, we will stay within the confines of the popular media. In what other country in this period would the government tourist board have published a guide such as *Alemania. Su moderna arquitectura* (*Germany. Its Modern Architecture*) [fig. 93],

fig. 91

fig. 92

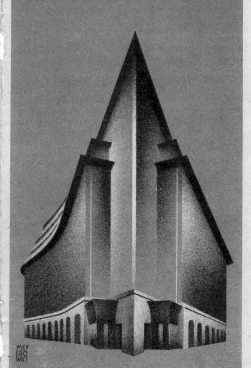

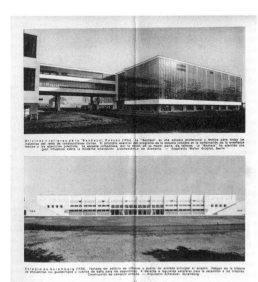

Oficinas y talleres de la "Bauhaus", Dessau (1926). La "Bauhaus" es una escuela profesional y técnica para todas las industrias del ramo de construcciones civiles. El principio esencial del programa de la escuela consiste en la combinación de la enseñanza teórica y los ejercicios prácticos. La escuela se compone, por lo tanto, en su mayor parte, de talleres. La "Bauhaus" ha ejercido una gran influencia sobre la moderna orientación arquitectónica de Alemania. — Arquitecto Walter Gropius, Berlín.

Estadio de Nuremberg (1928). Fachada del edificio de tribunas y puerta de entrada principal al estadio. Debajo de la tribuna se encuentran los guardarropas y cuartos de baño para los deportistas. A derecha e izquierda escaleras para la ascensión a las tribunas. Construcción de cemento armado. — Arquitecto Schweizer, Nuremberg.

19

fig. 93

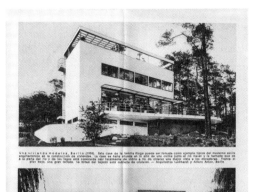

Una vivienda de modelo, Berlín (1930). Esta casa de la familia Kluge puede ser tomada como ejemplo típico del moderno estilo arquitectónico en la construcción de viviendas. La casa se halla situada en lo alto de una colina junto al río Havel y la fachada que da a la parte del río y de los lagos está construida casi totalmente de vidrio a fin de ofrecer una mejor vista a los miradores. Frente al piso bajo, una gran terraza. La mitad del tejado está cubierta de cristales. — Arquitectos Luckhardt y Alfons Anker, Berlín.

Vivienda de la familia Lange, Crefeld (1929—30). La casa, construida de ladrillo, es baja y muchas de las habitaciones tienen comunicación directa con el jardín. Las terrazas y balcones, así como las amplias ventanas, establecen una íntima comunicación entre los aposentos y el marco natural circundante. — Arquitecto Profesor Mies van der Rohe, Berlín.

30

Barrio de la Bruchfeldstrasse en Francfort del Main-Niederrad (1927). Por iniciativa y bajo la dirección de Ernst May, jefe que fue de los Servicios de Obras Públicas del Municipio de Francfort, han sido construidos en la periferia de la ciudad del Main diversos barrios de viviendas modelo. Todos ellos acusan el mismo estilo y se distinguen por la gran abundancia de jardines. Gracias a la disposición dentada de las casas, que el grabado permite reconocer, consiguió el arquitecto, a pesar de la desfavorable orientación del edificio, hacer llegar el sol a todas las viviendas. — Arquitecto Ernst May, en colaboración C. H. Rudloff.

mismo el estilo de los cinematógrafos construidos en las ciudades alemanas, vastos locales de diversión popular a base de un género que es, a su vez, también completamente nuevo. Más ligado a la tradición por su misma naturaleza, no se sumó al teatro, con idéntico entusiasmo, el movimiento renovador, pero es curioso hacer notar que la primera escena construida sin sujeción a los moldes arquitec-

tónicos tradicionales fué la "Volksbühne" o "Teatro Popular" de Berlín, inmensa sala de espectáculos destinada, como su nombre lo indica, a la divulgación del arte dramático entre las masas populares. Su autor Oskar Kauffmann renunció radicalmente a los rojos tapiceles, a las molduras marfileñas con ribetes dorados, inevitables hasta entonces en la decoración de todo teatro, y revistió totalmente el in-

37

with the keel of the Chilehaus in Hamburg on its front cover, an article by Max Osborn, and a generous selection of dozens of buildings inside, including works by Gropius, Taut, the Luckhardt brothers, Ernst May and Mies himself? A popular guide, then, to modern architecture in Germany, published at the end of the twenties in several languages, with the typical vertical drop-down format of the pocket guide: the fact is that much remains to be said about the popularizing of modern architecture.

On the full-colour cover of the issue of *Algo* dated 21 December 1929 [fig. 94], drawn by Femenía, we read: 'Glass Skyscraper. The German architect Mies van der Rohe has conceived and is in the process of realizing this project for a glass skyscraper.' Here we have, in effect, an unexpected view of Mies's 1922 project. It goes without saying that 1929 was the year of the Barcelona International Exposition for which Mies built the German Pavilion, but we will come to that in due course. For now let's take the suggestion of *Algo*'s editors and turn to the magazine's inside pages, where we find a fuller explanation and a photomontage, far less well-known than the photograph of the model we analysed above, whose 'original' version was published in another popular magazine—German, of course—from which *Algo* took the picture: *Wissen und Fortschritt*.[24] Among the curiosities of this image one is particularly striking: Mies's building discreetly displays, at the height of the first floor, a neon sign: Haller-Revue [fig. 95].

For season after season during the nineteen twenties the Admiralspalast theatre on Friedrichstraße hosted the Haller-Revue *variétés* shows featuring a version of the Tiller Girls [fig. 96]. The Mies skyscraper would also seem to be on Friedrichstraße, then, perhaps on the site of the famous theatre. In fact, Mies never said what his building was to accommodate, but what kind of desire was that neon sign, Haller-Revue, a response to? To start with, the spectacular shows of the Berlin Tiller Girls invoked a very precise modernity: American entertainment[25], expressed in the precise order of music and machine. In 1927, indeed, Siegfried Kracauer published his most celebrated article, 'The Mass Ornament',[26] which set out to analyse that order—and more, although his distinctions between *mass* and *people* are not what interest us here. 'In the domain of body culture,' he writes, '[...] tastes have been quietly changing. The process began with the Tiller Girls. These products of American distraction factories are no longer individual girls, but indissoluble girl clusters whose movements are demonstrations of mathematics.' This 'mass ornament'—the masses being, in turn, the support of the ornament— is, like the process of capitalist production, Kracauer tells us, an end in itself.

fig. 94

ALGO

AÑO I - NUM. 39

SEMANARIO ILUSTRADO ENCICLOPÉDICO Y DE BUEN HUMOR

REDACCIÓN Y ADMINISTRACIÓN: DIPUTACIÓN, 211, BARCELONA

21 DICIEMBRE DE 1929

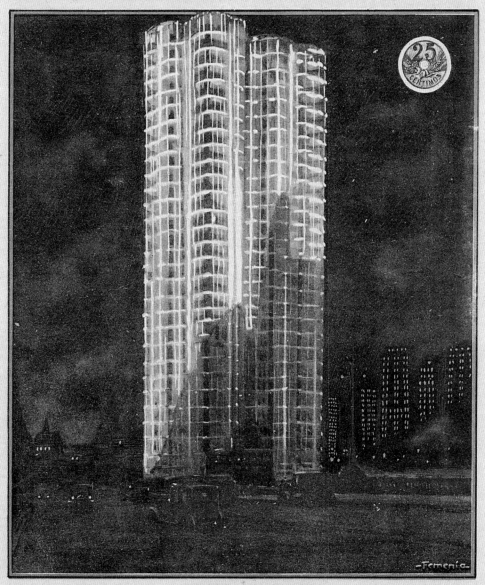

RASCACIELOS DE CRISTAL

El arquitecto alemán Mies van der Rohe ha concebido, y está en vías de realizarlo, este proyecto de rascacielos de cristal.

(Para la explicación detallada véase la pág. 10 de este número)

CON ESTE NÚMERO DEBE RECIBIR EL LECTOR LAS ENTREGAS GRATUITAS, QUE REPARTIMOS APARTE, DE

LA TIERRA Y SUS POBLADORES EL HUSAR AZUL Y DOS HOMBRES MALOS TEATRO SELECTO

(Geografía Universal) (Novela) (Obras teatrales)

'The hands in the factory,' he writes, 'correspond to the legs of the Tiller Girls,' and the mass movement of 'thousands of bodies, sexless bodies' taking place in the vacuum of their great geometric shapes can no longer be reassembled into individual human beings—the girls are identical and interchangeable with each other—but is disgregated in each thigh, each arm, each hand and each knee in a process of *perpetuum mobile*, of infinite and continuous assembly and disassembly, which is nothing but 'the aesthetic reflex of the rationality to which the prevailing economic system aspires'. In a way, Kracauer's comparison of their movements with those of the production line—just as geometric and precise, just as serial, just as American—presents the Tiller Girls to us as didactic instruments: their shows are a stage in the training—no paradox here—of the masses for a life that is no longer collective but choreographed, deprived of experiences. Surely this is why he asserts that the *'Ratio* of the capitalist economic system is not reason itself but a murky reason'. We have seen clearly enough that the reason of those skyscrapers is, in effect, a 'murky reason': X-rays, mist, nocturnal gloom... The modern spectacle is didactic, it teaches us how to live in shock, in a nervous state that is ultimately resolved in the great dance of starting all over again. That is what repeatedly occurred in the successive seasons of the Haller-Revue, but while we're at it, let's take a look at the 1926 show, the title of which was, precisely, *An und Aus*. Like so many American musicals in which skyscrapers played a part, here too all the girls lined up on stage raise their legs in unison in a perfect vertical at the exact pace of the conveyor belt, while behind them, at the same tempo, the skyscrapers and the whole city dance in step [fig. 96]. That neither Mies nor any of his assistants could find any other *ornament* for the façade of the glass skyscraper than the neon sign of the Haller-Revue can only be an unconscious, automatic response. Dancing skyscrapers are also products of the distraction factories.

Whatever the case may be, the *Algo* photomontage gives us *another* version. We know that the magazine's editors found that image not in a learned journal but in *Wissen und Fortschritt*, a popular magazine like their own. What concerns us now is, first, its timeliness—the photomontage was published in 1929, when the German Pavilion in Barcelona was still standing—and secondly, the way in which it was used and manipulated by our journalists and illustrators. On page 10 [fig. 97], in the section entitled 'Of The World and Life', next to a piece about 'the modern woman', who is necessarily sporty, a swimmer in a swimsuit— Kracauer described 'thousands of sexless bodies in swimsuits'—and surrounded by features on passenger seaplanes, on aircraft for children, on 'how to be loved madly', on intelligent animals, on motorcycles and motor cars, on the new craze

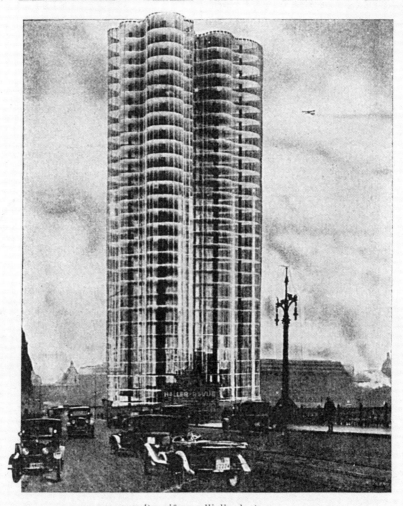

Der gläserne Wolkenkratzer
Ein Vorschlag zur Bebauung des Platzes am Bahnhof Friedrichstraße, Berlin
Das Modell stammt von Architekt Mies van der Rohe. (Vergleiche den Aufsatz: Glasarchitektur, eine ver-
wirklichte Utopie".) Combiphot: Hajek-Halke.

fig. 95

HALLER-REVUE

Aus dem BAR-BILD

CHAMPAGNER

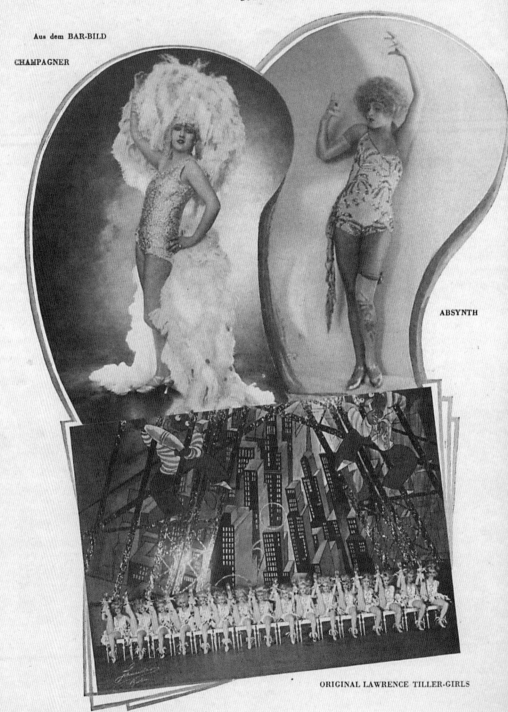

ABSYNTH

ORIGINAL LAWRENCE TILLER-GIRLS

in Paris for walking cats rather than dogs... in the midst of all of this we find the article entitled 'Glass Buildings'. Buildings, plural, because Mies's skyscraper is not alone: at the foot of the column is a drawing of a 'glass country house' by 'German professor Beherens' (sic), a star of points and edges, so that both skyscraper and house are presented in a relationship curiously similar to that between two 'expressionist' or 'still' expressionist buildings in the pages of *Frühlicht* [fig. 68] a few years earlier: Bruno Taut's expo pavilion with open-air cinema—a glass star also remarkably similar, in fact, to the house by 'Beherens'—and Mies's skyscraper. Curiously, or perhaps not so curiously: it is true that this house was among the projects published in the *Wissen und Fortschritt* article [fig. 99], and it is also true that *Algo* borrowed its subject matter and images from many sources, but, as we have seen and can readily imagine, these were mostly very similar popular European magazines. Even taking this into account, could we, then, not point to *Frühlicht* itself, with its very precise formal associations—glass skyscraper plus glass star—, as the most remote origin of these montages and compositions? Could we talk, without paradoxes, about 'collective unconsciousness'? On the 'casual' dissemination of avant-garde magazines, as I remarked before about avant-garde architecture itself, a great deal has yet to be written.

Although what we find in the pages of *Frühlicht*, as we have said, is the break between these last Expressionist efforts of Taut's and the productivism, at once crystalline and opaque, of Mies, the opposite happens in the popular magazine *Algo* where, as the article itself clearly asserts, Mies's skyscraper is presented as being in perfect harmony with Behrens's putative country house. Indeed, if the skyscraper represents modern life in the city, with its gleaming and knife-sharp but also repetitive and standardized image, the singularity of Behrens's star-shaped house symbolizes the extreme individualism of the private dwelling: an individualism that, like the rationalism deplored by Kracauer, can only be rendered murky—no paradox here again—by the glass: in this transparent house, in fact, the private is understood, in perfect resonance with the public condition of the skyscraper, as an *ex-position* of life rather than as private life, in a kind of extravagant popular modern interpretation of the old decorum. In any case, one thing is clear: the rhythm of the avant-garde architects is glaringly out of step with the popularization of their forms, cheerfully accumulating and overlapping this and that with no very fine distinctions as to creators, styles or chronologies, and ending up, quite simply, in the mass grave of a modernity that, like its progenitor Madame Fashion/Madame Death, makes no distinctions.

fig. 96

DEL MUNDO Y DE LA VIDA

Edificios de cristal
(Véase la portada de este número)

Rascacielos de cristal que va a construirse en Berlín y al que se refiere la portada de este número

ESTE rascacielos de cristal, que damos en la portada en colores, ha sido proyectado por el arquitecto alemán Mies van der Rohe y se va a construir en la plaza Bahnhof Friedrichstrasse, de Berlín. Este arquitecto asegura que el cristal será el material de construcción más empleado en el futuro, pues tiene la gran ventaja de dejar pasar la luz del sol, con lo que todos los pisos, además de claridad abundante, tendrán mejores condiciones higiénicas, ya que los rayos del sol constituyen el medicamento por excelencia para toda clase de enfermedades. Una particularidad muy notable del cristal que se empleará para esta construcción es la de que se verá de dentro afuera a través de él, pero no de fuera adentro.

OTRO proyecto de casa de cristal que también ha comenzado a realizarse es el del profesor alemán Behe-

Casa campestre de cristal

rens, el cual ha concebido esta casa de campo en forma de estrella. Esta no es sólo de cristal, sino que el metal

está combinado con él. Las vigas, por ejemplo, son metálicas, y las grandes planchas de cristal que forman las fachadas tienen también su marco metálico. Naturalmente, es un cristal tan fuerte como la piedra. De otro modo, no pasaría semana sin que hubiera que hacer la casa de nuevo. Lo de tener sol y luz todo el día y en todos los pisos es suficiente para que la idea sea digna de aplauso.

La mujer moderna

ESTA famosa nadadora neoyorkina, Mrs. Lottie Schoemmell, acaba de realizar una de sus frecuentes proezas: ha nadado atada de pies y manos una distancia de seis millas por el río Hudson. La señora de Schoemmell es casada y tiene hijos, pero por lo visto su esposo no la tiene muy sujeta, a pesar de las ligaduras con que aparece en nuestro grabado.

Avión para pasajeros

ESTE hidroavión, de la marca «Savoia-Marchetti», ha sido construido recientemente en Norteamérica y prestará sus servicios en una de las líneas aéreas del Nuevo Mundo. Podrá transportar catorce pasajeros y 2,500 kilogramos de carga útil. Es el tipo de aeroplano con el que el comandante

Pinedo recorrió 96,540 kilómetros. Los motores están montados en tándem y

desarrollan una fuerza de 500 caballos cada uno, pudiendo imprimir al avión una velocidad de 205 kilómetros por hora.

El avión más pequeño

ESTE aeroplano es de juguete, como puede ver el lector, pero vuela. Vuela muy corto trecho y a poca altura del suelo, pero su propietario — el pequeño piloto que se ve en la fotografía — se considera tan feliz como si volara por las nubes a través de los continentes. El niño es italiano y el minúsculo avión ha sido construído en Roma.

Para hacerse amar locamente

EL pingüino Alfredo (vedlo en el centro de la fotografía) es la mascota de los empleados del metro de París. Parece ser que desde que las metropolitanas parisienses tienen esta mascota se han casado el noventa por ciento de ellas y con hombres mucho más hermosos que el pingüino Alfredo. Lo tienen vestido de empleado del

metro y es el niño mimado de la compañía. Ya lo saben las metropolitanas españolas: tener un pingüino es tener un marido, y no crean los maridos que les insultamos.

vu à ce sujet la lettre du Capitaine Ferber ; peut-on franchir une frontière, une limite de douane ou d'octroi sans avertissement ? comment assurer l'identité du ballon, du dirigeable ou de l'aéroplane ? peut-on circuler dans l'air au-dessus des villes, villages, habitations et, en ce cas, à quelle hauteur minima ? comment croiser ou dépasser un autre appareil d'aviation ? etc., etc.

Autant de cas à examiner et de solutions à apporter dans le plus bref délai possible ; en effet, si les juristes se laissaient par trop devancer par les inventeurs, nous assisterions à une véritable anarchie dans le domaine des airs : les abus et les accidents ne se compteraient pas.

Il faut donc une réglementation internationale de la circulation aérienne, comme il y a des lois et des coutumes pour la circulation terrestre, fluviale et maritime.

C'est dans ce but qu'une conférence où seront représentées toutes les grandes nations européennes va se réunir à Paris prochainement.

Chacun des Etats participants se prépare actuellement, par des études minutieuses, à trouver les meilleures solutions.

Plusieurs d'entre eux ont déjà, le Gouvernement Français notamment, institué des commissions destinées à grouper les éléments

Le Comte de LAMBERT à Paris.

fig. 98

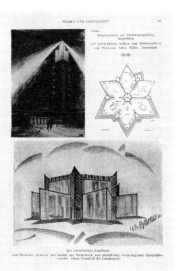

fig. 99

fig. 97

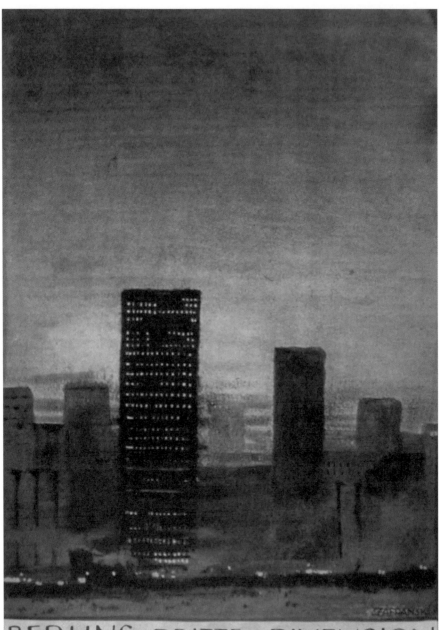

fig. 100

But let's focus on the representation of the skyscraper. In the photomontage published in *Wissen und Fortschritt* and in the inside pages of *Algo*, the Mies building seems to have found its natural place: the great metropolis. It has been uprooted from the strange isolation to which the illustration in *Frühlicht* had consigned it, confronting the city of plaster, of Gothic paste, and installed, as I say, amid the 'naturalness' of traffic and urban perspectives: apart from the sign advertising the Haller-Revue—which in any case no longer existed in 1928—we can see ultramodern cars, electric lights, steam and smoke, the mass of large buildings in the background, a railway station, a bridge, and even a plane travelling across the sky... Comparison of this montage with a beautiful and famous early twentieth-century photograph showing the Eiffel Tower with a bridge, a train and an airplane gives us the exact measure of the persistence of modern icons in the popular imagination [fig. 98]. This is by no means a merely formal question: right there are all of the elements of the montage that *Wissen und Fortschritt* and the *Algo* artists, playing the same game, laid out on the page with the Mies building.

In the image on the cover of the magazine [fig. 94]—signed, as we know, by Femenía, one of the magazine's regular illustrators—the manipulation is absolute, and absolutely interesting. Here the natural condition of the site of the most popular modernity has become even more intense. In contrast to what we see in the *Frühlicht* photograph, the skyscraper is lit 'properly' from inside, and radiates a pale red with yellow highlights reminiscent of neon signs; the shadows of other skyscrapers—which must therefore be just as high—fall on it, while in the background a skyline of big black box-like buildings with regular rows of lighted windows calls to mind so many typical depictions of the great city at night (for example, without straying from our present context of German popular magazines, the cover illustration of the *Berliner Morgenpost* brochure entitled *Three dimensional Berlin*) [fig. 100], so that the singularity in which Mies had originally placed his skyscraper is inevitably called into question. And all of this is figured in a greenish nocturnal setting of mist and electric light, characteristic of the cinematic vision of the city of the future in the populist present. The popular image, or the popular use of Mies's image is not, then, that of a break with the past but of its culmination. Here we clearly see the difference between the avant-garde, which sets out to represent the world from the unique perspective of the leader of the masses, and 'modern life', popular and populist, specular and spectacular in which all of the goals of progress have already been reached—'a realized utopia'[27]—and, finally, nothing remains to be done and nothing represents or stands for anything.

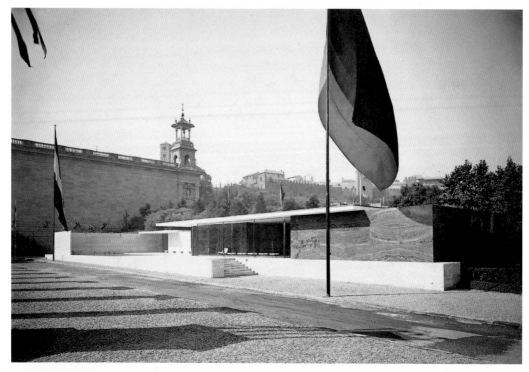

fig. 101

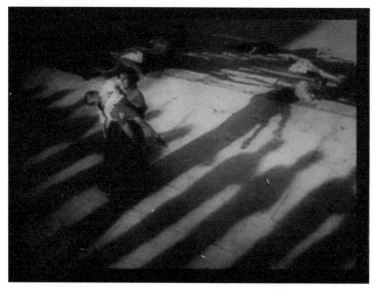

fig. 102

fig. 103

COLGOTHA

fig. 104

Having referred above to the German Pavilion, constructed in Barcelona in 1929, the year this issue of *Algo* was published, let's also take a look, first, at official photographs of the Pavilion and, secondly, at the sources of these and of the popular photographs [view central album]. We might note, for example, one of the most famous images of modern architecture and of the entire twentieth century: the shot of the Pavilion from the corner of the podium and the slightly foreshortened steps, with the silhouette of the Josep Puig i Cadafalch buildings and the Pueblo Español[28] behind it and the German flag billowing inflated in the breeze in the foreground [fig. 101]. And to start at the beginning, we could talk about the parallel shadows of the Ionic columns on the left of the photograph, entering from outside the frame.

The appearance of these shadows has at times been associated with some of the literally epic avant-garde moments, such as the scene in *Battleship Potemkin* [fig. 102] in which the soldiers' shadows also enter the frame diagonally from the left, parallel like those of the columns, and fall across the bodies of a mother and child. Some of the heat can be taken out of that heroic perception simply by paying attention to one or two of the mechanisms of early twentieth-century popular culture that have passed directly and unambiguously into high culture. Let's attempt a tour of these.

On the subject of shadows, we might think of Renoir's 1868 painting *Le Pont des Arts* [fig. 103]. On the quayside in the foreground we see the shadows of people on the Pont du Carrousel immediately downstream from the Pont des Arts, one of whom must of course be the painter himself. But why would it occur to Renoir to paint something like this, the shadows of people who are not in the picture but outside of it, looking at the scene inside the frame, something almost unprecedented in the history of painting and absent from its precepts? Obviously, he did so because this was one of the issues that had been raised by photography, though not, of course, by professional photography. If we take a look at popular amateur photography manuals from the late nineteenth and early twentieth centuries, we find that the 'self-shadow'—which occurs when the photographer's own shadow is cast into the field of the shot—is one of the faults they alert their readers to most insistently, and undoubtedly one of the most frequent. For example, a piece in *Photo-Revue* from 1901 headed 'The Photographer's Little Miseries' [fig. 105] warns against 'own-shadow manía',[29] and explains in detail how to avoid this un-

welcome surprise, though we need only leaf through an average family album to see that this advice is not so easy to follow, and that this classic slip, that this 'surprise', crops up remarkably often [fig. 106-108]. But what is interesting is to see how this typical gaffe of the amateur photographer passes into high art, starting with Renoir's pioneering adoption of it, and—what is most relevant to our purpose here—into avant-garde photography. It is worth looping back to the New York photographers of the *Camera Work* circle now to look at a famous photograph by Alvin Langdon Coburn, taken in 1912, and as pioneering as the Renoir painting, entitled *The Octopus* [fig. 109]: the shadow of a skyscraper, the Metropolitan Life building designed by Napoleon LeBrun and completed in 1909, falls across a snow-covered Madison Square as if it were the shadow of the photographer himself, grown to the stature of a giant. But it was the German avant-garde photographers of the nineteen twenties, precisely, who made this gaffe one of their favoured themes for experimentation, from László Moholy-Nagy, who often let his shadow fall on his dazzled *victims*—the camera always high, always looking down at a sharp angle, the subject always horizontal, lying on the ground, exactly as in the frames of *Battleship Potemkin*, which says a great deal about the ultimate meaning of the uses of photography—to the photo-books published in the course of the decade, which never failed to include a few pictures featuring a self-shadow, as can be seen, to give just one famous example, in a double page from Werner Gräff's book *Es Kommt Der Neue Fotograf!* (Here comes the new photographer!),[30] published in 1929, precisely [fig. 110].

But to carry on in this line would take us back to the heroic narrative centred on the avant-gardes, and avant-garde artists were by no means the only ones to avail themselves of this resource. In 1868, the same year that Renoir painted *Le Pont des Arts*, an academicist *pompier* artist, Léon Gérôme, exhibited a courageous canvas entitled *Consummatum est*. What we see on Golgotha are not the three crosses of the crucifixion but the distant silhouette of Jerusalem under an ominous stormy sky and, in the foreground, a vast rocky landscape with the shadows of the three crosses falling diagonally from outside the pictorial space, dramatically entering the scene from the right. This is, of course, the rhetorical, emotive dramaticism demanded by an impressionable—popular—religiosity. Indeed, the extraordinary popularity of this painting by Gérôme is demonstrated by the great number of engravings and prints that were made from it [fig. 104]. And surely it was just this kind of sentimental rhetoric, this ostentatious theatricality so characteristic of *pompier* painting that supplied the aesthetic, rhetorical and scenographic model for the blockbuster movie productions of

Les
PETITES MISÈRES DU PHOTOGRAPHE

L'Auto-Ombromanie

La photographie que nous reproduisons ci-dessous, et que nous devons à un de nos abonnés, n'est pas à proprement parler entachée de défectuosité accidentelle ; elle devrait rentrer plutôt dans la catégorie de ces anomalies que nous avions appelées autrefois les *Surprises du Gélatino...*

La particularité qui nous engage à la placer sous les yeux de nos lecteurs, bien qu'elle ne présente par ailleurs aucun intérêt immédiat comme composition ou exécution, réside exclusivement dans l'ombre portée au premier plan par l'opérateur et par la personne placée à ses côtés.

Le soleil était fortement incliné sur l'horizon ; ses rayons frappaient nos personnages sous une obliquité telle que leur ombre s'allongeait, démesurée, au point d'entrer en partie dans le champ embrassé par l'objectif.

La netteté de cette ombre révélatrice n'est pas troublée par les inégalités du terrain. L'incidence des rayons quant au plan de l'écran où ils la projettent, ne la déforme pas non plus d'une façon appréciable. Ceci tient à ce que la marche des rayons qui forment l'image

Fig. 1. — L'ombre de l'opérateur dans la composition.

dans l'appareil est presque parallèle à la direction de la lumière solaire, ainsi que le démontre le schéma Fig. 2).

On reconstitue facilement l'attitude des deux personnages : on voit que l'opérateur, utilisant son appareil selon la méthode qui permet de viser à la hauteur de l'œil, tournait le flanc droit au sujet.

Il semble qu'on reconnaîtrait à leurs silhouettes les deux auteurs de la scène, devenus acteurs à leur insu, et de cette constatation on infèrerait volontiers qu'il doit être facile de baser sur cette sorte d'auto-silhouettage non prémédité, une nouvelle méthode d'ombromanie photographique.

Rien ne serait plus simple que d'imaginer un système d'écran inclinable, permettant de donner aux ombres enregistrées une absolue correction, comme aussi de les déformer facultativement en longueur, en largeur, en diagonale, etc.

Par exemple, un écran plan, disposé de façon à être perpendiculaire à la bissectrice de l'angle formé par les rayons du soleil et l'axe de l'objectif ; conserverait aux ombres des proportions rigoureusement exactes.

Des mouvements d'inclinaison tendant à rapprocher de l'objectif soit l'un des côtés latéraux, soit l'une des extrémités supérieure ou inférieure de l'écran, déformeraient les silhouettes dans des sens différents et les transformeraient en charges plus ou moins plaisantes, que l'esprit d'à propos de l'opérateur pourrait à l'occasion rendre spirituelles.

Il nous suffira d'avoir esquissé le thème de cette application pour qu'elle soit le point de départ de distractions d'un nouveau genre, et pour que les chercheurs y trouvent matière à des observations intéressantes que nous reproduirons s'il y a lieu.

Le chapitre des *Récréations photographiques* n'est pas la partie la moins utile de notre programme : non seulement, elle contribue à nous amener des adeptes, mais elle peut retenir et charmer l'amateur blasé que rebute l'automatisme des opérations courantes.

René d'Héliécourt.

Fig. 2. — Schéma de la marche des rayons.

fig. 105

fig. 106

fig. 107, 108

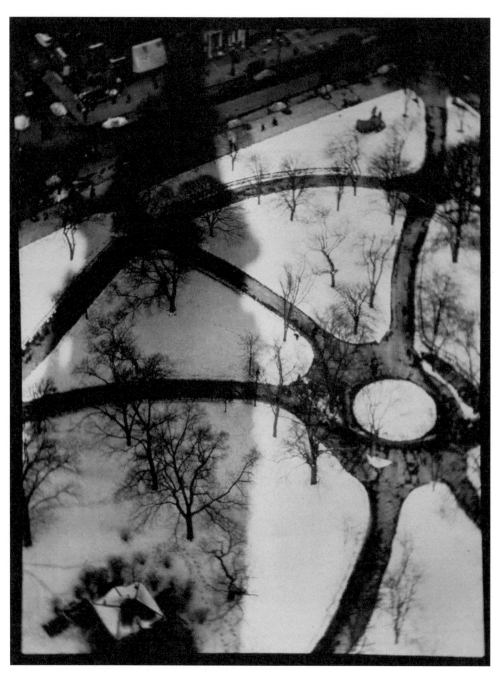

fig. 109

Und Aufnahmen mit der Sonne:
„Der Fotograf hüte sich, den eigenen Schatten mit aufs Bild zu bekommen."

Werner Gräff, Oranienburg

Achten Sie immerhin darauf. Aber seien Sie nicht zu ängstlich! Auch das kann
reizvoll sein! (Hier sind sogar die Schatten zweier Fotografen drauf!)

„Ein Bild darf nur ein Motiv haben." So? Warum denn? Im Leben passieren
doch wohl auch die verschiedensten Dinge nebeneinander.
Etwas anderes ist es, daß es einfacher ist, ein Bild mit nur einem Motiv zu
meistern. Man mag Ihnen allenfalls empfehlen, sich einfache Motive zu suchen.
Das ist in der Ordnung. Aber verbieten soll man Ihnen absolut nichts.

the early twentieth century, belonging essentially to the genre known as history films? We might recall Cecil B. DeMille's two biblical films of the twenties, *The Ten Commandments* (1923) and, above all, *King of Kings* (1927), to exemplify the kind of commercial models we are referring to and the kind of popular success we are talking about. When we place the Gérôme painting, the Eisenstein film still and the photograph of the German Pavilion side by side we see how much we must qualify the heroism of the avant-garde and the extent to which we must recompose its sources and reinterpret its mechanisms on the basis of *ornament*: popular culture or, more precisely, mass culture.

But let's talk about the essential *game* of the avant-garde, in which, there is always an implicit prefix of deprival: *dis-*. For instance, of what disappears in the official photographs of the Pavilion, and becomes visible, but visible in its absence, terribly visible, when we compare these with the casual photographs taken by amateurs or reporters: the *dis*-placement of scale, the *dis*-inflation of the flag, the *dis*-mantling of the doors, the *dis*-appearance of the adjacent buildings... These things are known, but, in truth, only half known. In the pictures in the official photographic record of the Mies Pavilion retouching, from the building itself to the photographic plates, has become a method: there has been a systematic erasing, a persistent elimination, a lasting exclusion. What is more, these modes of representation, these carefully groomed photographs are of a building that would *dis*-appear as such within a few months, and as such they speak to us of what the architect was willing to show, because after them nothing would remain; however, when we compare them with the ingenuous pictures taken by amateurs and reporters, these betrayed images also speak to us of everything that, in contrast, the popular gaze can take in.

———————

In a private collection in Barcelona there is an anonymous photograph of the German Pavilion, until recently unpublished [album 7]. This is an absolutely extraordinary document, first because it is a stereoscopic image, so we could say—forgetting, of course, facsimile reproductions and accepting the fanciful tangibility of the medium—that it alone offers us the possibility of 'seeing' the three dimensions of the Pavilion in its true time and in its original place; and secondly because, in effect, this is the true time and the original place of the Pavilion, in the sense that this photograph, unlike most of those that have officially survived, almost always solitary and empty, uprooted from temporality,

The New Woman and the Old Man.
Copyrighted 1892, by William B. Rau.

fig. 111, 112

shows its day-to-day presence: people, visitors, 'pass' through it as they would—
as they did—pass through any of the many others constructed for the occasion. A
stroll after the rain: people walk through the German Pavilion, perhaps as a short-
cut, in the course of a visit to the Exposition.

In 1929, as also in its golden age in the first twenty years of the second half
of the nineteenth century, stereoscopic photography could have no other pur-
pose than a parlour amusement [fig. 111-112]. Indeed, by this time—the age of
radio, cinema, sports, mass media...—it was already an anachronism, an eccentric
amusement. The image of the Pavilion [fig. 114] is just one of the hundreds that
our anonymous photographer took in the grounds of the International Exposi-
tion in Barcelona [fig. 113]. Like many other photographers, as we well know, he
preferred to take shots on rainy days and, in many cases, at night. If the Barce-
lona Exposition was initially conceived as a celebration of the electric industry,
there could be no better time to capture its essence than when the illuminated
fountains, the streetlamps on the avenues and the lights of the motor cars were
reflected in the wet pavements and multiplied to infinity. These conditions were
also particularly suited to the nature of stereoscopy and its need to 'fill' the image,
not only with buildings and objects but also with a chaotic scattering of bright
reflections against which the gaze, in its desire for depth, could collide here and
there in the endlessly restless to and fro that the medium encourages: both in
front and behind. Those bourgeois interiors absolutely replete with things, in
which the gaze convulsively stops and starts, have been replaced here by urban
exteriors, sometimes nocturnal but always bright, which seem to demand an
even more spasmodic vision, and in which the reflection is the object to be en-
countered. In the stereoscopic photograph of the Pavilion that primary condition
seems fully realized: after the rain, the wet ground rivals the surface of the pool,
and walls, flags, columns and people are doubled fragmentarily in the puddles. Or
so it seems...

On the left of the photograph a wall recedes in rapid perspective, pointing to
the statue by Kolbe on the inside pool, but that wall could not be caught on cam-
era. Literally: where it should have been we have the blurred forms of the garden
shrubs opposite it and the towers of the neighbouring pavilion outlined against
the clear sky, and we see the white line of the roof slab and the underside of the
slab above our heads merge directly into their respective continuations on either
side of the mirror formed by the polished marble. All that remains of this wall is
its thickness, reduced to a narrow dark vertical strip with which the arrisses of

the slabs form a double cross in the air. The material Pavilion, casually snapped by a photographer with no pretensions beyond simple amusement, as the case is here, seems to refuse to grant the mark of its presence to photography. This art of contact, whose condition is realist, so to speak, has nothing to do with it: the Pavilion concedes to the negative only images of the 'other side', or its own ghostly projection, but not what it is: a mere invisible support of a quality that is extraordinary but absolutely devoid of 'virtues', opaque, mute.

The mysteries of vacancy: without them the Pavilion would not exist; it exists to support them. The wet floor and the reflections are, in this case, vulgar, a poor redundancy, and we can imagine the bewilderment of our accidental photographer on discovering, eyes eagerly applied to the viewer, that despite having met all the requisite conditions of the stereoscopic technique, that this was a failed photograph, a photograph incapable of 'entertaining' and anything but 'familiar'. Indeed, while stereoscopic photography promises the eye a heightened tangibility, the Pavilion was constructed on the principle of the most ritual intangibility: that of the superlatively petrified, that of the precious mineral, that of the many-faceted diamond that does everything and nothing in its quiet sparkling; and if stereoscopic photography proposes a world in which we can alternatively be in front of things and behind them, the Pavilion stands not as a thing but as nothing but air, air hardened on a pedestal, always passing through its own walls, traversing itself; or like an angel, one of whose virtues, the beloved –for Mies- Aquinas tells us, is the ability to be first in one place and then in another without passing through the space between. A terrible virtue, without doubt: enclosed everywhere, here and there, frozen in its own perfection of Nothing and Nowhere.

The Pavilion repels the contact of photography. The world of picturesque reflections can expect nothing from the great metaphor of the time of the identical—of the time of Hell—that is the gigantic unglinting reflection of the Pavilion, devastatingly Unique; it can hope for nothing but ridicule: reflections—thus, in the plural—are laughable compared to the Time of forever frozen smiles, the ceremony of never-ending inauguration, of the eternity after the rain, of the abolition of temporality.

It has rightly been said that the stereoscopic view is inherently obscene, but what could be more obscene than the Pavilion where everything is shown so that there is nothing left to apprehend? The Pavilion is the most terrible sphinx because its enigma stares us in the face and says both *Orto* and *Nihil*.

fig. 113

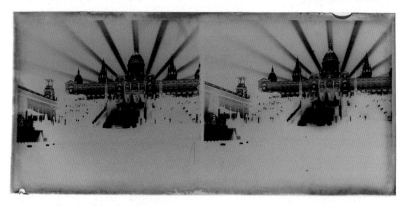

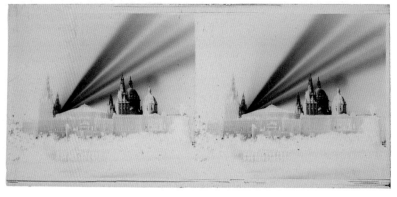

This, without paradox, is the order with which the infernal time of modernity is activated: *fotografieren verboten*, 'no photographs'.

And yet there it is, nevertheless: photography. Petrification is the essential condition of metaphors, and we are accustomed to seeing petrified movements in images of the Pavilion: that of the statue, previously frozen by the art of representation, or that of the flags, instantaneously frozen by the art of contact. Here we also see, as we have said, that of the people who pass through, the passers-by. To them, finally, our gaze is directed, and with them it collides and pauses: the couple walking unhurriedly arm in arm, that thin man in black who approaches the edge of the pedestal with hunched shoulders, that group at the back just about to go down the steps... We will look at the reflection, we will leave our eyes in it, and will see nothing more than a little idol. And yet: coats, hats, furs, bodies somewhat hunched against the cold that has followed definite concrete rain on that autumn afternoon. It has turned chilly: these bodies, as accidental as the photographer, all with their backs to the Pavilion, all on the point of leaving it, tell us that it had, indeed and in spite of everything, its place and its time. It beggars belief: the place and the time in which Mies, raising as no one had ever done before a monolith of still air on a pedestal, thwarted the finest opportunity architecture ever had to avoid its decline, its best chance of suppressing itself in the very instant of attaining its greatest beauty and its absolute perfection.

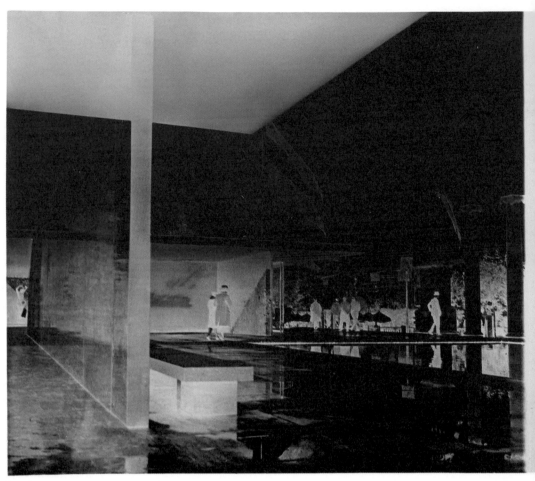
fig. 114

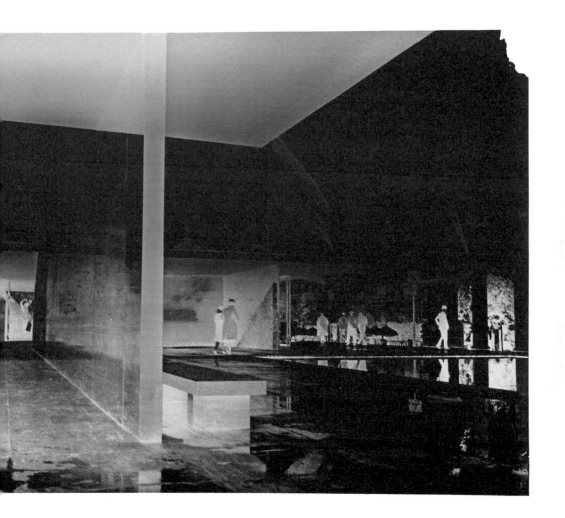

NOTES

1. Kracauer, Siegfried. 'Locomotive über der Friedrichstraße', *Frankfurter Zeitung*, 28 January 1933, republished in id., *Strade a Berlino e altrove*, pp. 44-46, edited by Pisani, Daniele. Bologna: Pendragon, 2004.

2. In ch. 4 of part III, 'Skyscraper': John Dos Passos, *Manhattan Transfer*. New York: Harper & Brothers, 1925.

3. See Robles Tardío, Rocío. *Pintura de humo*. Madrid: Siruela, 2008.

4. *Frühlicht*, No. 4, pp. 122-124. K. Peters: Magdeburg, summer 1922.

5. Colomina, Beatriz. *Domesticity at War*, ch. 5. Cambridge: MIT Press, 2007.

6. Kevles, Bettyann Holtzmann. *Naked to the Bone*, p. 1. Reading, Massachusetts: Helix Books, Addison-Wesley, 1997.

7. Mann, Thomas. *Der Zauberberg*, 2 vols. Berlin: S. Fischer, 1924. All quotes, with minor revisions, are from the

Spanish translation by Verdaguer, Jacint. Id., *La montaña mágica*, 2 vols., Barcelona: Apolo, 1934.

8. Mann, Thomas. 'Einführung in den Zauberberg', a lecture given at Princeton University on 10 May 1939 and published as an introduction to id., *The Magic Mountain*. New York: Alfred A. Knopf, 1962.

9. In the 'Propósito' to *La montaña mágica*, cit., vol. 1, p. 11.

10. Op. cit., vol. 2, p. 12.

11. Op. cit., vol. 1, p. 278.

12. Op. cit., vol. 1, pp. 311 and 428.

13. Op. cit., vol. 1, p. 283.

14. Op. cit., vol. 1, p. 278.

15. Op. cit., vol. 1, p. 279.

16. 'May the spirit of Walt Whitman guide the Indeps. Long live his memory, and long live the Indeps!', in *The Blindman*, No. 1. New York, 10 April 1917, p. 6, devoted to the *Exhibition of Independent Artists*.

17. My thanks to Ton Salvadó for drawing my attention to this plate.

18. Le Corbusier, *Urbanisme*. p. 185. Paris: Crès, 1925.

19. *ABC: Beiträge zum Bauen*, N°2, pp. 2-3.Thun, Basel: ABC, 1924.

20. 'Modernes Bauen 3', *ABC*, cit., pp. 3-5.

21. Satō Giryō (ed.) *Gendai ryōki sentan zukan*, pp. 198-199. Tokyo: Shinchōsha, 1931.

22. Taut, Bruno. *Die Stadtkrone*. Jena: Verlegt bei Eugen Diederichs, 1919.

The same thing is apparent in the illustrations of books—by no means avant-garde—that exalt the German as *conditio sine qua non*—as the author claimed—of the essence of the Gothic, such as Worringer, W. *Formprobleme der Gotik*. Munich: Piper & Co., 1922.

23. Brunet, Laura. 'Bosquejo histórico sentimental de la vida, grandezas y dolores de la ciudad de Barcelona' [Sentimental historical sketch of the life, grandeurs and pains of the city of Barcelona], *La Ilustración Ibero-Americana*, vol. I, year II, No. 3, Barcelona, 1929, n. p. There is also another double-page illustration of the 'Barcelona of the Future' inspired by the project that N. M. Rubió i Tudurí presented in the Pavilion of the City at the International Exposition in 1929.

24. The photomontage, signed by H. Hajek-Halke, appeared on the front cover of *Wissen und Fortschritt: Populäre Monatsschrift für Technik und Wissenschaft* [*Knowledge and Progress: Popular Monthly Journal of Technology and Science*], No. 1, Berlin, April, 1927, as a 'Glass skyscraper. Proposal for construction of the

square at the Friedrichstraße station', as derived from a Miesian 'model'. In the inside pages there is a fully illustrated article devoted to glass architecture: K. Dieth, 'Glasarchitektur, eine verwirklichte Utopie', pp. 91-97. There is another version of this photomontage: same place, same cars... but the skyscraper presents the arris, and not the curves, in the foreground.

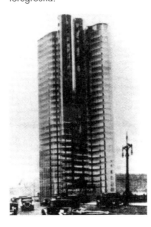

25. Although the Tiller Girls were originally an English phenomenon, in the German imaginary of the time they embodied American modernity, as we can see in Kracauer.

26. 'Das Ornament der Masse' first published in *Frankfurter Zeitung*, 9-10 June 1927. Kracauer, Siegfried. *The Mass Ornament. Weimar Essays*, pp. 75-79, trans. Thomas Y. Levin. Cambridge: Harvard University Press, 1995.

27. As we read in the very title of the article by K. Dieth, 'Glasarchitektur, eine verwirklichte Utopie', cit.

28. Josep Puig i Cadafalch (1867-1956) was the architect who designed the first master plan of the Barcelona International Exposition and the author of the Ionic columns that stood in front of the German Pavilion. The Pueblo Español was a picturesque collage of popular architecture from various parts of Spain.

29. See Chéroux, Clément. *Fautographie. Petite histoire de l'erreur photographique*, p. 68 and ff. Liège: Yellow Now, 2003.

30. Gräff, Werner. *Es kommt der neue Fotograf!* pp. 32-33. Berlin: Hermann Reckendorf, 1929.

LIST OF ILLUSTRATIONS

Photography or Life

1. Loos, Adolf. Langer house, Vienna, 1901. Photograph c. 1930. Kulka, Heinrich (ed.). *Adolf Loos: das Werk des Architekten.* Vienna: Anton Schroll & Co., 1931.

2. Loos, Adolf. Khuner house, Vienna, 1907. Photograph c. 1930. Kulka, Heinrich (ed.). *Adolf Loos: das Werk des Architekten.* Vienna: Anton Schroll & Co., 1931.

3. Loos, Adolf. Löwenbach house, Vienna, 1913. Photograph c. 1930. Kulka, Heinrich (ed.). *Adolf Loos: das Werk des Architekten.* Vienna: Anton Schroll & Co., 1931.

4. Loos, Adolf. Goldman & Salatsch shop, Vienna, 1898. Photograph c. 1901.

5. Loos, Adolf. Goldman & Salatsch shop, Vienna, 1898. Photograph c. 1901.

6. Advert for F. O. Schmidt, in *Das Andere,* 1, p. 17. Vienna, 1903.

7. Loos, Adolf. Goldman & Salatsch shop, Vienna, 1898. Photograph c. 1901. Glück, Franz. *Adolf Loos.* Paris: Crès, 1931.

8. Loos, Adolf. *Adolf Loos's apartment,* Vienna, 1903. Photograph 1903. © Albertina, Vienna.

9. Loos, Adolf. *Adolf and Lina Loos in the fireplace alcove of his apartment,* 1903. © Albertina, Vienna.

10. *Loos in front of his fireplace,* 1929.

11. Loos, Adolf. *Fireplace alcove of the Adolf Loos apartment,* 1909.

12. Loos, Adolf. Tristan Tzara house, Paris, 1926-1927. Kulka, Heinrich (ed.). *Adolf Loos: das Werk des Architekten.* Vienna: Anton Schroll & Co., 1931.

13. Loos, Adolf. Müller house, Prague, 1930. Photograph c. 1930.

14. Loos, Adolf. Müller house, Prague, 1930. Photograph c. 1930. Glück, Franz. *Adolf Loos.* Paris: Crès, 1931.

15. Loos, Adolf. Tristan Tzara house, Paris, 1926-27. Photograph c. 1930. Kulka, Heinrich (ed.). *Adolf Loos: das Werk des Architekten.* Vienna: Anton Schroll & Co., 1931.

16. Le Corbusier, Villa Stein, Garches, 1928.

L'Architecture Vivante, Spring 1929. Paris: Éditions Albert Morancé, 1929. © F.L.C./VEGAP, Barcelona 2015.

17. Gertrude Stein's apartment at 58, rue Madame, Paris. Collection of the San Francisco Museum of Modern Art Archives, gift of Albert S. Bennett, New York.

18. Le Corbusier, Villa Stein, Garches, 1928. *L'Architecture Vivante,* Spring, 1929. Paris: Éditions Albert Morancé, 1929. © F.L.C./VEGAP, Barcelona 2015.

19. Gertrude Stein's apartment at 27, rue de Fleurs, Paris. *Gazette des Beaux-Arts,* 30 March 1934. Paris: Gazette des Beaux-Arts, 1934.

20. Le Corbusier, Villa Stein, Garches, 1928. Le Corbusier; Jeanneret, Pierre. *Le Corbusier Oeuvre Complète.* Zürich: Girsberger, 1935. © F.L.C./VEGAP, Barcelona 2015.

21. Matisse, Henri. *Studio with Goldfish,* 1912. *L'Esprit Nouveau,* 22. Paris: Crès, 1924. © Succession H. Matisse/ VEGAP/Barcelona 2015.

22. Moholy, Lucia. *Bauhaus Building in Dessau, Workshop façade from southwest (oblique view).* 1925/6.

Bauhaus-Archiv Berlin.
© VEGAP, Barcelona, 2015.

23. Itting, Gotthardt. *Bauhaus Building in Dessau, corner of the main staircase to the workshop building*. 1926/8.
Bauhaus-Archiv Berlin.

24. Moholy-Nagy, László. *Malerei Fotografie Film*. Munich: Langen, 1925. Cover.
© VEGAP, Barcelona, 2015.

25. Kranz, Kurt. *Self-portrait superimposed on the Bauhaus sign*, 1930.

26. Kárász, Judith (attributed to). *Double exposure Otti Berger and Bauhaus*, 1931/2.
Bauhaus-Archiv Berlin.

27. Rose, Hajo. *High jumper in front of the Prellerhouse*, 1930.
Bauhaus-Archiv Berlin, © VEGAP, Barcelona 2015.

28. Feininger, Theodore Lux. *Impromptu comedy on the playing field*, Georg Hartmann with fleuret, c. 1929.
Bauhaus-Archiv Berlin. © Estate of T. Lux Feininger.

29. Feininger, Theodore Lux. *The building as a stage*, 1928.
Bauhaus-Archiv Berlin. © Estate of T. Lux Feininger.

30. 'Neue Wege der Photographie', example from Graff, Werner. *Es Kommt der*

Neue Fotograf! Berlin: H. Reckendorf, 1929.

31. Renger-Patzsch, Albert. *Die Welt ist Schön*, Munich: K. Wolff, 1928.
© Albert Renger-Patz- Archiv/ Ann und Jürgen Wilde/VEGAP, Barcelona 2015.

32. Photographer unknown, *Aerial view of Ford River Rouge Plant*, c. 1927.

33. Sheeler, Charles. *Bar and Billet Mill Motor Room – Ford Plant*, 1927.
© The Lane Collection. Courtesy Museum of Fine Arts, Boston.

34. Sheeler, Charles. *Ladle Hooks, Open Hearth Building – Ford Plant*, 1927.
© The Lane Collection. Courtesy Museum of Fine Arts, Boston.

35. Sheeler, Charles. *Stamping Press – Ford Plant*, 1927.
© The Lane Collection. Courtesy Museum of Fine Arts, Boston.

36. Sheeler, Charles. *Criss-Crossed Conveyors – Ford Plant*, 1927.
© The Lane Collection. Courtesy Museum of Fine Arts, Boston.

37. Sheeler, Charles. *Pulverizer Building – Ford Plant*, 1927.
© The Lane Collection. Courtesy Museum of Fine Arts, Boston.

38. Sheeler, Charles. *Power*

House No. 1 – Ford Plant, 1927.
© The Lane Collection.
Courtesy Museum of Fine Arts, Boston.

39. Sheeler, Charles. *Industry*, 1927, Gelatin silver collage (triptych), 20 x 7 cm.
Julien Levy Collection, 1146a-c, The Art Institute of Chicago.
© The Art Institute of Chicago.

40. Gallonio, Antonio. *SS. Martyrum cruciatibus*. Cologne, 1602.

41. Circle of the Master of the Martyrdom of the Apostles. *Sts. Felix, Regula and Exuperantius broken with the wheel*, c. 1480
© Keresztény Múzeum, Esztergom. Photograph by Attila Mudrák.

42. Heartfield, John. Preliminary photomontage for *Wie im Mittelalter… so im Dritten Reich*, 1937.
Courtesy of John Heartfield Exhibition. © The Heartfield Community of Heirs/VEGAP, Barcelona 2015

43. Heartfield, John. *Wie im Mittelalter… so im Dritten Reich*, 1937.
Akademie der Künste, Berlin, Kunstsammlung, Inv.-Nr.: Heartfield 780. © The Heartfield Community of Heirs/VEGAP, Barcelona 2015

44. Monleón, Manuel. ¡Obreros!, este es vuestro porvenir, si triunfa el fascismo, 1936.

45. Strand, Paul. *Skeleton/ Swastika, Connecticut*, 1936. © Aperture Foundation Inc., Paul Strand Archive. Courtesy of Philadelphia Museum of Art.

46. *Documents*, 6. Paris: G. Bataille, 1929.

Popular Mies

47. Mies van der Rohe, Ludwig. *Friedrichstraße Skyscraper Project, entry in the Friedrichstraße skyscraper competition, photograph of lost photo-collage*, Berlin, 1921. © 2015. Digital image, The Museum of Modern Art, New York/Scala, Florence/VEGAP, Barcelona 2015.

48. Mies van der Rohe, Ludwig. *Contribution 'Wabe' (honeycomb) to the ideas competition for a skyscraper at Friedrichstraße station*, Berlin, 1922. © Bauhaus-Archiv Berlin, Foto: Markus Hawlik/VEGAP, Barcelona 2015.

49. Friedrichstraße Station. Berlin, Postcard, Berlin, c. 1915.

50. Mies van der Rohe, Ludwig. *Friedrichstraße Skyscraper Project, perspective of north-east corner*, Berlin, 1921. © 2015. Digital image, The Museum of Modern Art, New York/Scala, Florence/VEGAP, Barcelona 2015.

51. Röntgen, Wilhelm Conrad. *The hand of Bertha Röntgen (first human radiography)*, Lennep, 22 December 1895. © German Roentgen Museum, Lennep.

52. Grashey, Rudolf. *Atlas de Röntgenogramas típicos del cuerpo humano normal*. Barcelona: Labor, 1928. 1st edition: *Atlas typischer Röntgenbilder vom normalen Menschen*. Munich: Lehman, 1905.

53. Stieglitz, Alfred. *The Hand of Man*, 1902. *Camera Work*, 1, January 1903. © Georgia O'Keeffe Museum/ VEGAP, Barcelona 2015.

54. *Camera Work*, 1, January 1903. Cover.

55. Stieglitz, Alfred. *The City of Ambitions*, 1910. *Camera Work*, 36, October 1911. © Georgia O'Keeffe Museum/ VEGAP, Barcelona 2015.

56. Coburn, Alvin Langdon. *The Flatiron*, 1912. © George Eastman House, International Museum of Photography and Film.

57. Steichen, Edward. *The Flatiron – Evening*, 1904. *Camera Work*, 14, April 1906. Archivo Fotográfico Museo Nacional Centro de Arte Reina Sofía. © Estate of Edward Steichen/VEGAP, Barcelona 2015.

58. Stieglitz, Alfred. *The Flatiron*, 1902. *Camera Work*, 4, October 1903. © Georgia O'Keeffe Museum/ VEGAP, Barcelona 2015.

59. The Flatiron, in *New York Illustrated*, 1910.

60. Berlage, Hendrik Petrus. *Amerikaansche Reisherinneringen*, Rotterdam: W.L. & J. Bruse, 1913.

61. Mies van der Rohe, Ludwig. Skyscraper for the Chicago Tribune. *L'Architecture Vivante*, Autumn 1925. © VEGAP, Barcelona, 2015.

62. Lloyd, Harold. Still from the film *Never Weaken*, 1921. © Harold Lloyd Entertainment, Inc.

63. Fraser, John Foster. *L'Amerique au travail*, Paris: P. Roger, 1910. Cover and inside pages.

64. Le Corbusier. 'Les temps modernes (l'Acier)'. *L'Esprit Nouveau*, 21. Paris: Crès, 1923. © F.L.C./VEGAP, Barcelona 2015.

65. Stieglitz, Alfred, *Old and New New York. Camera Work*, 34, October 1911. Archivo Fotográfico Museo Nacional Centro de Arte Reina Sofía. © Georgia O'Keeffe Museum/ VEGAP, Barcelona 2015.

66. Le Corbusier. 'Un building... On met du verre autour', *Urbanisme*, Paris: G. Crès, 1924. © F.L.C./VEGAP, Barcelona 2015.

67. *ABC: Beiträge zum Bauen*, 2. Basel: ABC, 1924.

68. *Frühlicht*, 4. Model of Mies van der Rohe´s glass skyscraper next to a project by Bruno Taut. K. Peters: Magdeburg, 1922.

69. Ruegenberg, Sergius. *Mies van der Rohe Caricature*, c. 1925. © Berlinische Galerie, Landesmuseum für Moderne Kunst, Fotografie und Architektur. Photo: Kai-Annett Becker.

70. Scharoun, Hans. *Architectural Phantasy*, for the book *Ruf zum Bauen*, Berlin: Wasmuth, 1920. Akademie der Künste, Berlin, Hans-Scharoun-Archiv, 2352. © VEGAP, Barcelona, 2015.

71. Scharoun, Hans. *Architectural Phantasy*, for the book *Ruf zum Bauen*, Berlin: Wasmuth, 1920. Akademie der Künste, Berlin, Hans-Scharoun-Archiv, 2373. © VEGAP, Barcelona, 2015.

72. Mendelsohn, Erich. 'Broadway at night', *Amerika; Bilderbuch eines Architekten*. Berlin: R. Mosse, 1928.

73. Poelzig, Hans. *Grosse Schauspielhaus*, Berlin, 1919. Published in Teichmüller, Joachim. *Lichtarchitektur*. Berlin: Union Deutsche Verlagsgesellschaft Zweigniederlassung, 1927.

74. Hilberseimer, Ludwig. 'Die neue Geschäftsstrasse', *Das Neue Frankfurt*, 4. Frankfurt am Main: Englert und Schlosser [1929].

75. Satō Giryō (ed.). Gendai ryōki sentan zukan [*Modern Bizarre; A Cutting-Edge Illustrated Guide*]. Tokyo: Shinchōsha, 1931.

76. Mies van der Rohe, Ludwig. *Glass Skyscraper, elevation (schematic view)*, 1922. © 2015. Digital image, The Museum of Modern Art, New York/Scala, Florence/VEGAP, Barcelona 2015.

77. *G: Material zur Elementaren Gestaltung*, 3. Berlin, 1924. Mies drawing in the cover. © VEGAP, Barcelona, 2015.

78. Poelzig, Hans. *View of Alley, photograph of the sets of the film The Golem*, 1920. Courtesy of Architekturmuseum TU Berlin, Inv. Nr. 2822.

79. *Frühlicht*, 3. K. Peters: Magdeburg, 1922.

80. Taut, Bruno. *Die Stadtkrone* [The City Crown], Jena: Verlegt bei Eugen Diederichs, 1919. Cover and inside pages.

81. *Scientific American*, 26, June 1909. New York: Scientific American, 1909.

82. *Algo: semanario ilustrado, enciclopédico y de buen humor*, 12 April 1930. Barcelona: Algo, 1930. Cover by Femenía.

83. *Midtown and Empire State Building*, New York. Postcard, New York, c. 1930.

84. Robida, Albert. *Le vingtième siècle*. Paris: E. Dentu, 1883 [6th edition]. Cover.

85. Robida, Albert. *Le vingtième siècle*. Paris: G. Decaux, 1883 [1st edition]. Cover.

86. *Algo: semanario ilustrado, enciclopédico y de buen humor*, 16 November 1929. Barcelona: Algo 1929. Cover by Larraya.

87. Brunet, Laura. 'Will this Via Laietana built by a visionary ever become a reality?' *La Ilustración Ibero-Americana*, vol. I, year II, n°3. Barcelona: La Ilustración Ibero-Americana, 1929.

88. King, Moses. *Views of New York*. New York: Moses King, 1911.

89. Lambert, Jaques, after a project by Auguste Perret. 'L'Avenue des Maisons Tours', *L'illustration*, 12 August 1922. Paris: L'illustration, 1922.

90. Corbett, Harvey Willey. *Metropolis of Tomorrow*, 1913. Published in *L'illustration*, 9 August 1913. Paris: L'illustration, 1913.

Originally published in *Scientific American*, 26 july 1913.

91. *Festplatz & Kugelhaus* [Fairground & Ball House]. Postcard. Dresden, 1929.

92. *Algo: semanario ilustrado, enciclopédico y de buen humor*, 22 March 1929. Barcelona: Algo 1929. Cover by Bocquet.

93. *Alemania. Su moderna arquitectura*. Barcelona: Sociedad Central Alemana de Atracción de Forasteros, 1929.

94. *Algo: semanario ilustrado, enciclopédico y de buen humor*, 21 December 1929. Barcelona: Algo, 1929. Cover by Femenía.

95. *Wissen und Fortschritt: Populäre Monatsschrift für Technik und Wissenschaft*, 1. Berlin, 1927. Cover by Heinz Hajek-Halke.

96. Lawrence Tiller-Girls. *Haller-Revue An und Aus*, Berlin, 1926. Courtesy Deutsches Tanzarchiv, Cologne.

97. *Algo: semanario ilustrado, enciclopédico y de buen humor*, 21 December 1929, p. 10. Barcelona: Algo, 1929.

98. Estournelles de Constant, d' Baron. *L'Aviation triomphante*. Paris: Librarie Aéronautique, 1909.

99. *Wissen und Fortschritt: Populäre Monatsschrift für Technik und Wissenschaft*, 1. Berlin, 1927. Courtesy of the Library of the Humboldt University of Berlin.

100. *Berlins dritte dimension*, Berlin: Berlin Ullstein, 1912. Supplement with the newspaper Berliner Morgenpost of 27 November 1912.

101. *Berliner Bild Bericht.* Barcelona Pavilion, 1929. © Mies van der Rohe Foundation.

102. Eisenstein, Sergei. Film still from *Battleship Potemkin*, 1925.

103. Renoir Pierre-Auguste. *Le Pont des Arts*, 1868.

104. Eichens, Hermann. *Golgotha, Consummatum est.* Paris: Goupil, 1871.

105. Hélicourt d', René. 'Little miseries of the photographer. Self-shadowmania', *Photo-Revue*, 52, 29 December 1901. Paris: Mendel, 1901.

106. Amateur photo with the photographer's shadow in the frame. Venice, c. 1909.

107. Amateur photo with the photographer's shadow in the frame. Buenos Aires, 1928.

108. Amateur photo with the photographer's shadow in the frame. New York, 1920.

109. Coburn, Alvin Langdon. *The Octopus*, New York, 1912. © George Eastman House, International Museum of Photography and Film.

110. Gräff, Werner. 'Oranienburg', *Es Kommt der Neue Fotograf!* Berlin: H. Reckendorf, 1929.

111. *-Oh! What a Load.* Illinois?, c. 1892. Slightly Cubist humorous stereoscopic photograph.

112. *The New Woman and the Old Man.* The Universal Art Company, Naperville, Illinois, 1892. Slightly Duchampian humorous stereoscopic photograph.

113. Anonymous stereoscopic photographs of the Barcelona International Exposition. Negatives and positives on glass plate, 1929. Private collection.

114. Anonymous stereoscopic photograph of the German Pavilion. Negative on glass plate. Barcelona, 1929. Private collection.

ALBUM ILLUSTRATIONS

LIVED INSTANT AND FROZEN CREATURE:
Album of the Barcelona Pavilion, 1929.

The German Pavilion opened on May 27, 1929. The Official Catalogue of the German Section of the Barcelona International Exposition of 1929 indicates that Georg von Schnitzler was the 'general commissioner', E. W. Maiwald and Baron von Kettler the 'general managers', Mies van der Rohe the 'chief architect', Lilly Reich the 'artistic director' and Karl Strauss the 'technical director'.

1. View across the large pool of water. Photo: Berliner Bild-Bericht. © Fundació Mies van der Rohe.

2. Pots of flowering plants in front of the façade of the German Pavilion during the International Exposition in Barcelona in 1929. Photo: Gabriel Casas. © ANC/ Gabriel Casas i Galobardes/ ANC1-5-N-19098

3. King Alfonso XIII is received on the podium of the German Pavilion by the authorities. To his right is Georg von Schnitzler, general commissioner of the German delegation at the Barcelona Exposition. Between them is Queen Victoria Eugenie of Battenberg (with a bouquet of flowers) and in the background the German Ambassador, Count Johannes von Welczeck. On the far left of the photograph, the man in profile holding hat and gloves is Mies van der Rohe. Photo: Brangulí. © ANC/ Brangulí (Fotògrafs)/ANC1-42-N-10978

4. The king and queen of Spain, Alfonso XIII and Victoria Eugenie of Battenberg, accompanied by the princesses Beatriz and Maria Cristina de Borbón. Barcelona, 1929. Photo: Brangulí. © ANC/ Brangulí (Fotògrafs)/ANC1-42-N-10979

5. 'The king and queen visit the German Pavilion, one of the Expo's most acclaimed buildings. A corner of the Pavilion.' *Diario Oficial de la Exposición Internacional de Barcelona*, 12, 1929. Barcelona: Compañía Nacional de Publicidad, 1929. Photo: Maymó.

6. Victoria Eugenie of Battenberg and Count Johannes von Welczeck, the German Ambassador. Behind him, with top hat on, is Mies van der Rohe. Photo: Brangulí. © ANC/ Brangulí (Fotògrafs)/ANC1-42-N-10977

7. Stereoscopic photograph of the German Pavilion. Glass plate negative, Barcelona, 1929. Photo: PLC. Private collection, Barcelona.

8. Alfonso XIII accompanied by Georg von Schnitzler. Photo: Brangulí. © ANC/ Brangulí (Fotògrafs)/ANC1-42-N-10976

9. View of the Pavilion from the office area. Barcelona, 1929. Photo: Berliner Bild-Bericht. © Fundació Mies van der Rohe.

10. While the king and the German Ambassador are still at the top of the stairs, Victoria Eugenia of Battenberg has already left the Pavilion. At her side, Georg von Schnitzler partially covers the metal sign of Köstner und Gottschalk, the firm that supplied the travertine, an advertisement that was carefully erased from the official photos. In the Pavilion's windows we see the reflection of the Ionic columns by the architect Josep Puig i Cadafalch, who drew up the general plan of the Expo.

Photo: Gabriel Casas.
© ANC /Gabriel Casas i
Galobardes/ ANC1-5-N-36

11. A crowd of onlookers and photographers watching the departure of the king. Photo: Brangulí. © ANC/ Brangulí (Fotògrafs)/ANC1-42-N-10980

12. 'The Pavilion of Germany on the day of its official opening.' Barcelona Atracción, 218, August 1929. Barcelona: Sociedad de Atracción de Forasteros, 1929. Photographer unknown.

13. View from the illuminable Glass Wall into the interior. Photo: Berliner Bild-Bericht. © Fundació Mies van der Rohe.

14. Interior with illuminable Glass Wall and Onyx Wall. Photo: Berliner Bild-Bericht. © Fundació Mies van der Rohe.

15. 'Germany.' La Ilustración Ibero-Americana, 2, 1929. Barcelona: La Ilustración Ibero-Americana, 1929. Photographer unknown.

16. The Barcelona Pavilion. Photo: Berliner Bild-Bericht. © Fundació Mies van der Rohe

17. The Barcelona Pavilion. Photo: Berliner Bild-Bericht. © Fundació Mies van der Rohe

18. View of the main entrance. Photo: Berliner Bild-Bericht. © Fundació Mies van der Rohe

19. View from the rear entrance to the office area. Photo: Berliner Bild-Bericht. © Fundació Mies van der Rohe

20. Three views of the artistic German Pavilion of great originality. Diario Oficial de la Exposición Internacional de Barcelona, 14, 1929. Barcelona: Compañía Nacional de Publicidad, 1929. Photographer unknown.

21. The German Pavilion. Barcelona, 1929. Photographer unknown. Private collection, Barcelona.

22. 'The official German pavilion, built with great austerity of lines and an extraordinary wealth of materials, is one of the most impressive. Marble, glass, nickel; indirect lighting. In one of the departments of this pavilion is the pool of water featured elsewhere in this special. A sculpture that adorns it is the only note of liveliness amid

the severe lines.' D'Ací i d'Allà, special issue [1929]. Barcelona: Editorial Catalana, 1929. Photographer unknown.

23. 'The simple, geometric German Pavilion appears with an extraordinary modernity.' Diario Oficial de la Exposición Internacional de Barcelona, 14, 1929. Barcelona: Compañía Nacional de Publicidad, 1929. Photographer unknown.

24. The Barcelona Pavilion. Photo: Berliner Bild-Bericht. © Fundació Mies van der Rohe

25. The Barcelona Pavilion. Photo: Berliner Bild-Bericht. © Fundació Mies van der Rohe

26. 'A view of the German Pavilion. A pool between the dark marble and a statue in white marble, which is reflected in it.' D'Ací i d'Allà, special issue [1929]. Barcelona: Editorial Catalana, 1929. Photographer unknown.

27. The Barcelona Pavilion. Photo: Berliner Bild-Bericht. © Fundació Mies van der Rohe

28. The German Pavilion at night. Photo: Berliner Bild-Bericht. © Fundació Mies van der Rohe

INDEX